# Gauguin
## The Other World

*To Frédéric, Daniel, Liliane and Nicole, who*
*supported my work, each in their own way.*
*Thank you.*
*F. D.*

*"No one can make history who is not willing to risk*
*everything for it, to carry the experiment with his own*
*life through to the bitter end and to declare that his life*
*is not a continuation of the past, but a new beginning."*

Carl Gustav Jung

Fabrizio Dori

# Gauguin
## The Other World

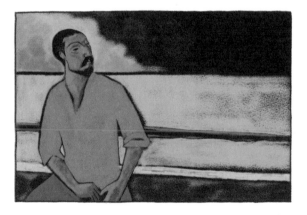

First published in English in 2016
by SelfMadeHero
139-141 Pancras Road
London NW1 1UN
www.selfmadehero.com

Written and illustrated by Fabrizio Dori
Translated from French by Edward Gauvin

English edition
Publishing Director: Emma Hayley
Sales & Marketing Manager: Sam Humphrey
Publishing Assistant: Guillaume Rater
UK Publicist: Paul Smith
US Publicist: Maya Bradford
Designers: Shahriar Shadab and Txabi Jones
With thanks to: Dan Lockwood and Nick de Somogyi

A CIP record for this book is available from the British Library

ISBN: 978-1-910593-27-1

10 9 8 7 6 5 4 3 2 1

Printed and bound in Slovenia

In days gone by, the islands of Ra'iātea and Taha'a were but a single vast land: Havai'i-nui, "the Great Space Summoned and Gained".

There, priests built the Marae Taputapuātea. It was decided that nothing must disturb the peace of this sacred place - that there, no rooster would crow, nor any human being ever trespass.

Tere-he, a beautiful young woman whose name meant "Evil Intent", defied this taboo. Day after day, she came to bathe in the waters of the river that flowed by the temple.

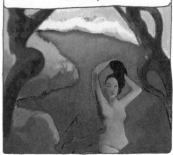

Displeased by her behaviour, the gods sent Tuna-nui, the Big Eel, which swallowed the young woman whole.

Possessed by the spirit of Tere-he, the Eel grew wrathful. In a fury, it uprooted trees and dislodged rocks. It devoured half the island's inhabitants. In consuming everything around it, Tuna-nui swelled until it became a gargantuan creature.

Then the gods asked Tarahu-nui, the Great Shaman, to intervene.

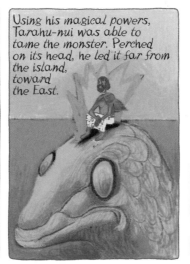

Using his magical powers, Tarahu-nui was able to tame the monster. Perched on its head, he led it far from the island, toward the East.

From then on, the Great Eel was known as the Great Transfigured One.

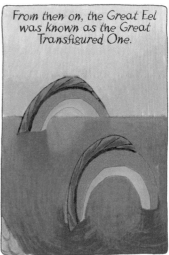

7

Its tall, razor-edged dorsal fin became the mountain chain from which the island of Tahiti grew. A second, smaller dorsal fin formed the spine of the isle of Mo'orea.

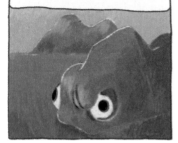

After which the gigantic fish, exhausted, slept. But keeping it from moving was no easy task. A party of warriors set out on an expedition. They reached the island of Tahiti in an outrigger canoe. They wished to sever the Eel's tendons, so that it would never budge again.

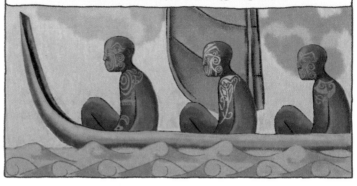

Among them was the renowned Tafa'i. He'd fashioned an enormous axe, the sturdiest axe ever made. The weapon was so heavy that no man could lift it.

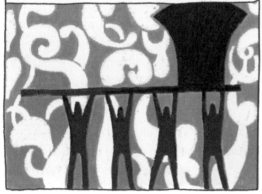

Tafa'i called on Tino-rua, Lord of the Ocean, and the axe became so light that a child could wield it.

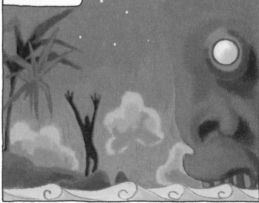

Tafa'i severed all the Eel's muscles and tendons. And on that day, Tahiti became the island we all know now.

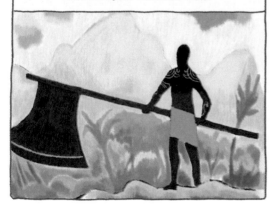

Tafa'i and his warriors became the island's kings. Many generations later, their descendants saw an ancient prophecy come true. It said, "One day, men will come in a great canoe with no soul. They will be clothed from head to toe."

On the night of 8 June 1891, after sixty-three days of sailing, Paul Gauguin reached Tahiti. The island, first discovered in 1767 by English explorers, had become a French colony in 1880.

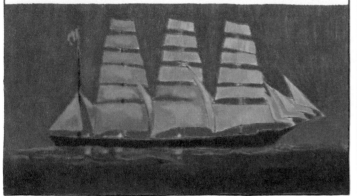

Gauguin disembarked in Papeete, a port city founded by the British missionary William Crook in 1818. In Polynesian, its name means "water from a basket".

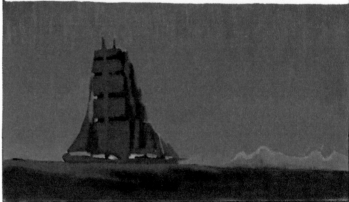

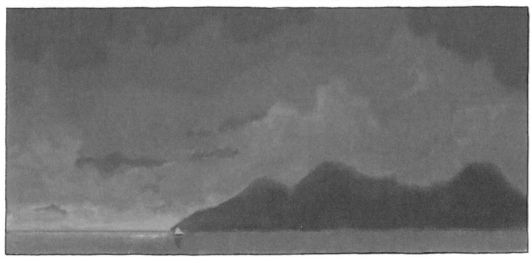

Gauguin had bid farewell to Europe and the life he had lived up until that moment.

"May the day come when I'll flee into the woods on an island in Oceania, there to live on ecstasy, stillness and art."

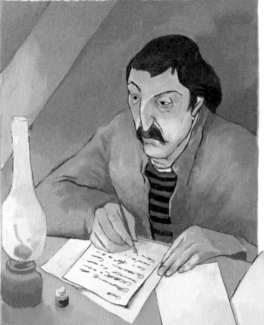

"Surrounded by a new family, far from the European struggle for money."

"There, in Tahiti, in the silence of the beautiful tropical nights, I shall be able to listen to the sweet murmuring music of my heart's movements in loving concert with the mysterious beings around me..."

"Free, at last, from financial concerns, I shall be able to love, sing and die."

# 1
# Manao tupapau

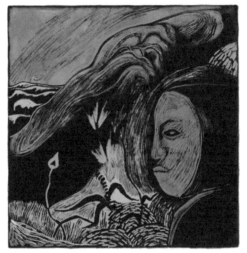

# Spirit of the dead watching

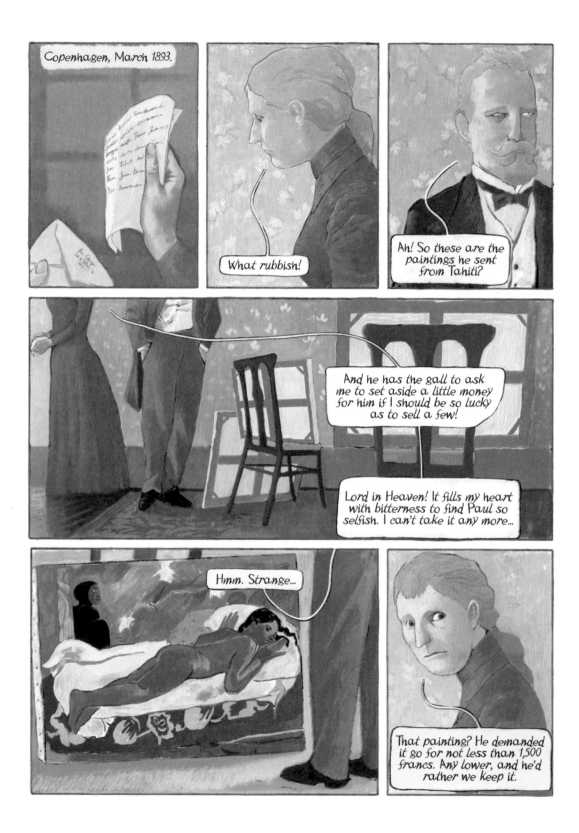

Copenhagen, March 1893.

What rubbish!

Ah! So these are the paintings he sent from Tahiti?

And he has the gall to ask me to set aside a little money for him if I should be so lucky as to sell a few!

Lord in Heaven! It fills my heart with bitterness to find Paul so selfish. I can't take it any more...

Hmm. Strange...

That painting? He demanded it go for not less than 1,500 francs. Any lower, and he'd rather we keep it.

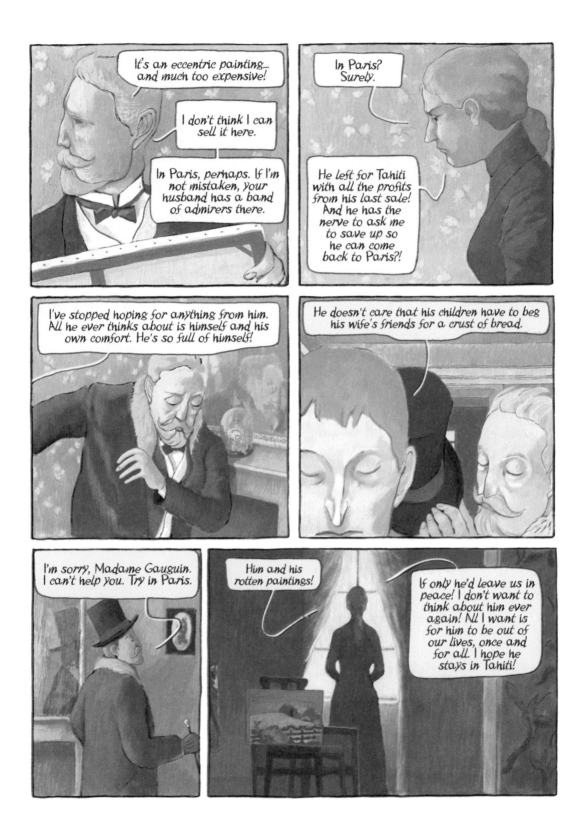

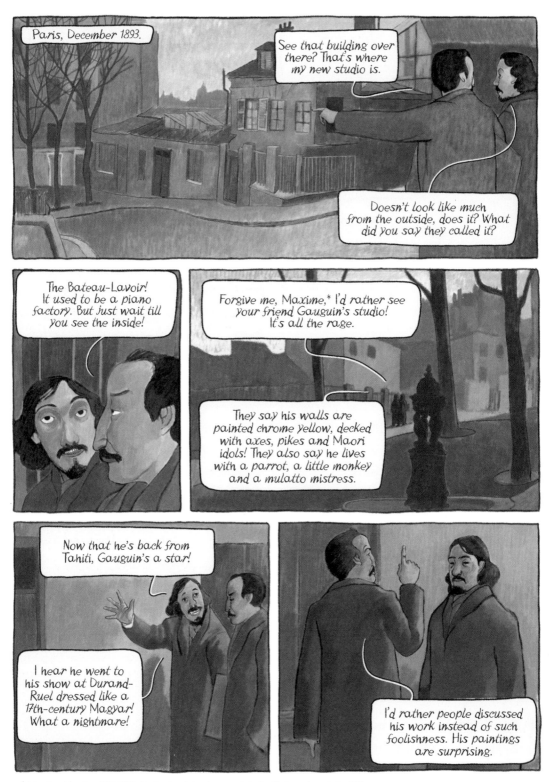

* Maxime Maufra (1861-1918), the first painter to move into the Bateau-Lavoir in 1893.

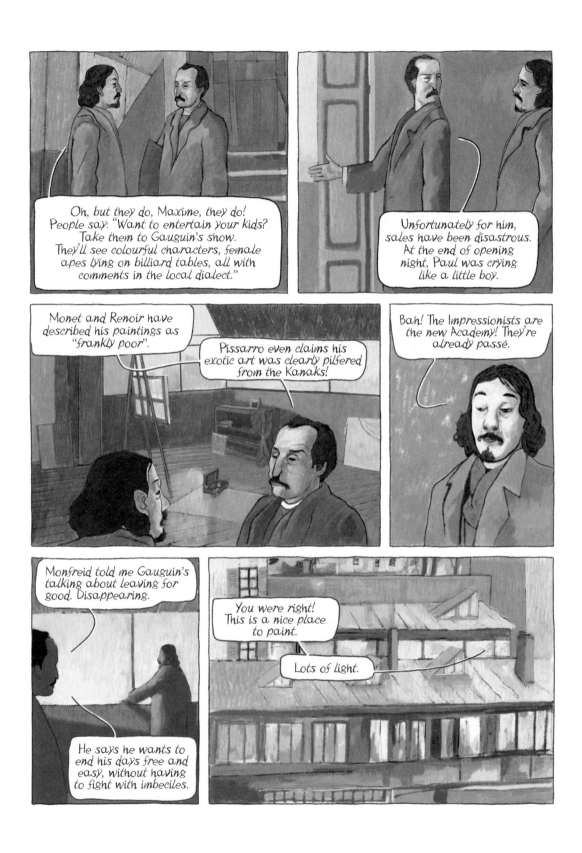

Oh, but they do, Maxime, they do! People say: "Want to entertain your kids? Take them to Gauguin's show. They'll see colourful characters, female apes lying on billiard tables, all with comments in the local dialect."

Unfortunately for him, sales have been disastrous. At the end of opening night, Paul was crying like a little boy.

Monet and Renoir have described his paintings as "frankly poor".

Pissarro even claims his exotic art was clearly pilfered from the Kanaks!

Bah! The Impressionists are the new Academy! They're already passé.

Monfreid told me Gauguin's talking about leaving for good. Disappearing.

He says he wants to end his days free and easy, without having to fight with imbeciles.

You were right! This is a nice place to paint.

Lots of light.

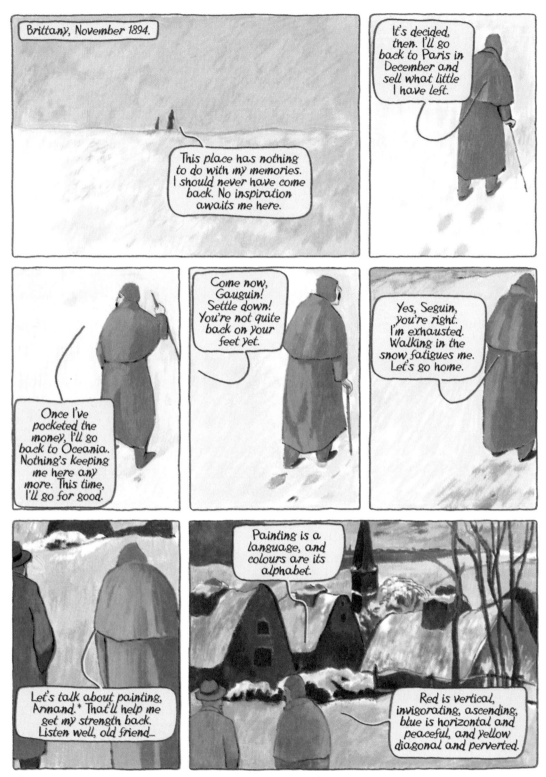

Brittany, November 1894.

This place has nothing to do with my memories. I should never have come back. No inspiration awaits me here.

It's decided, then. I'll go back to Paris in December and sell what little I have left.

Once I've pocketed the money, I'll go back to Oceania. Nothing's keeping me here any more. This time, I'll go for good.

Come now, Gauguin! Settle down! You're not quite back on your feet yet.

Yes, Seguin, you're right. I'm exhausted. Walking in the snow fatigues me. Let's go home.

Let's talk about painting, Armand.* That'll help me get my strength back. Listen well, old friend...

Painting is a language, and colours are its alphabet.

Red is vertical, invigorating, ascending, blue is horizontal and peaceful, and yellow diagonal and perverted.

* Armand Séguin (1865-1903), painter and illustrator, a friend to Gauguin, Émile Bernard and Sérusier.

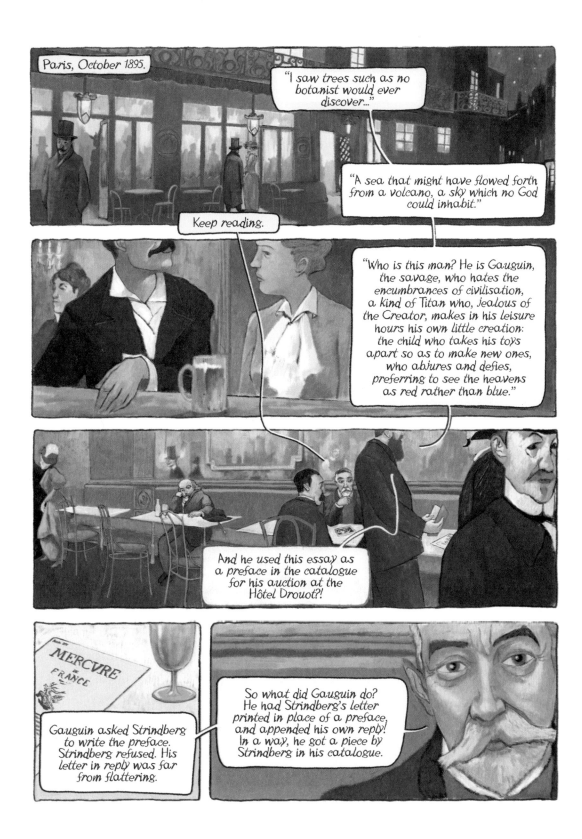

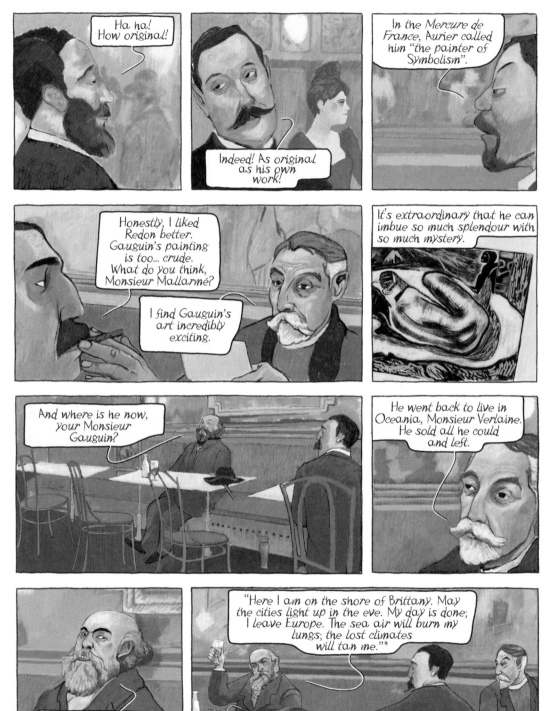

* Rimbaud - A Season in Hell.

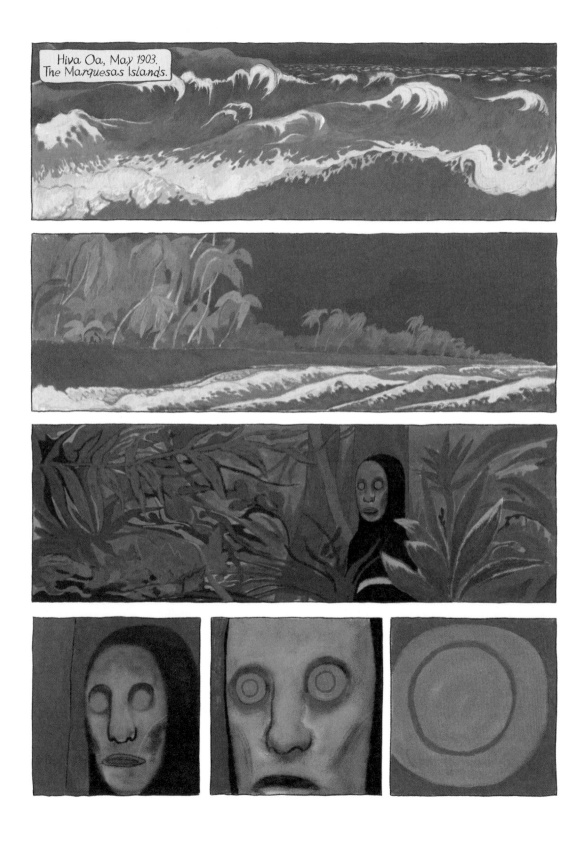

Hiva Oa, May 1903.
The Marquesas Islands.

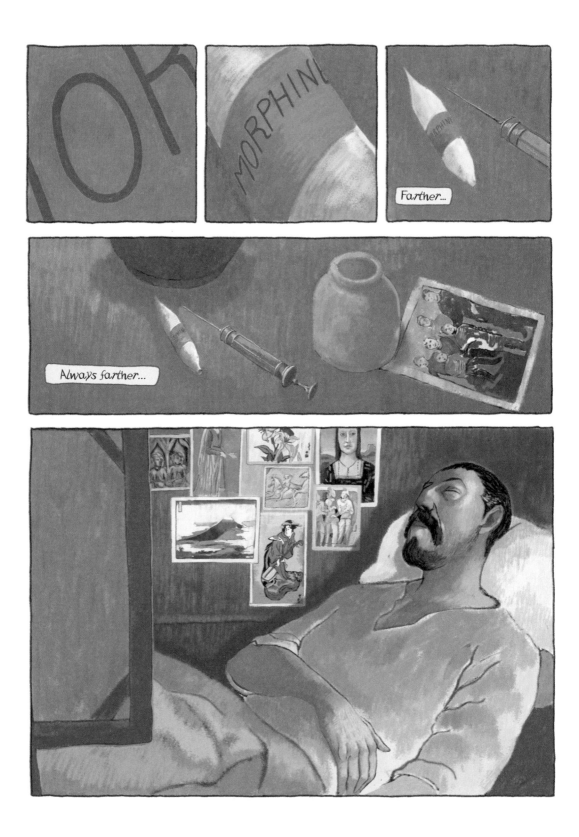

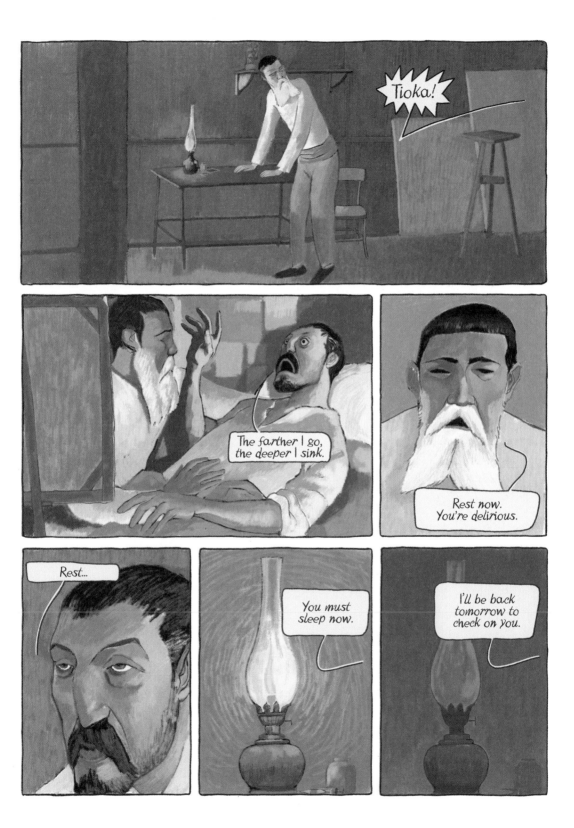

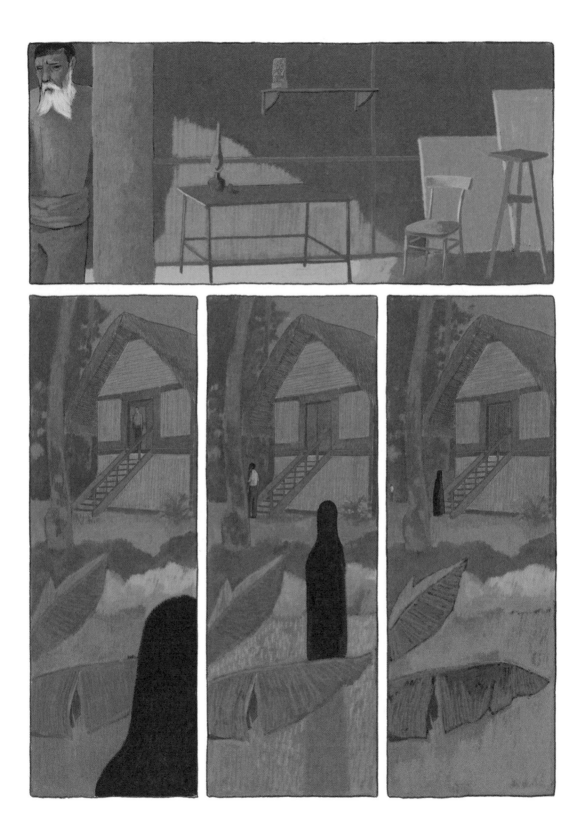

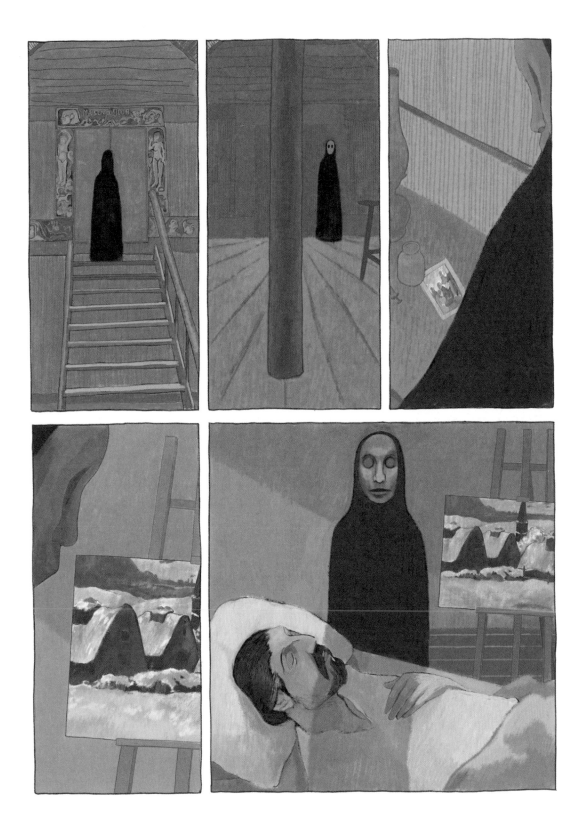

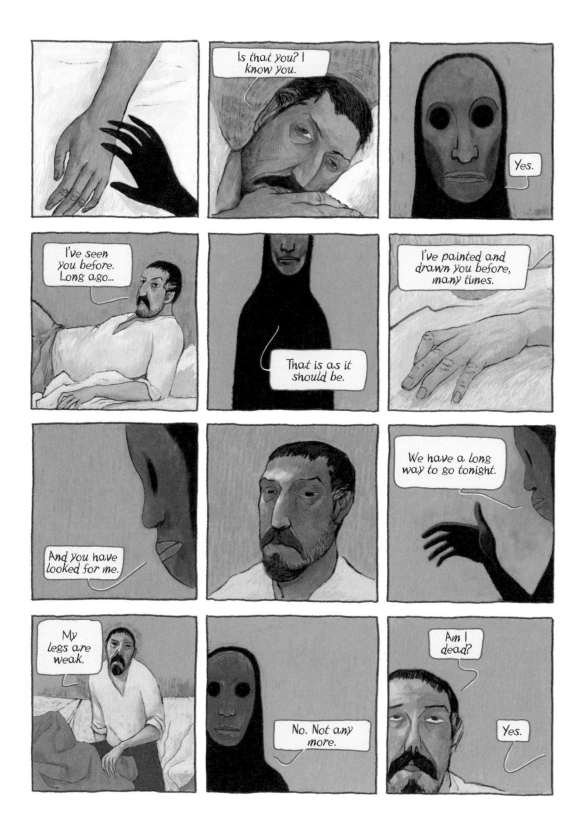

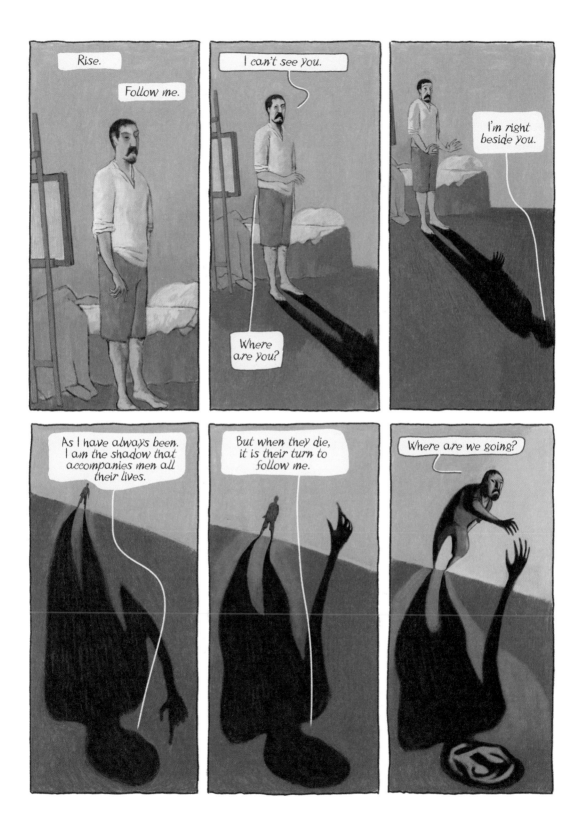

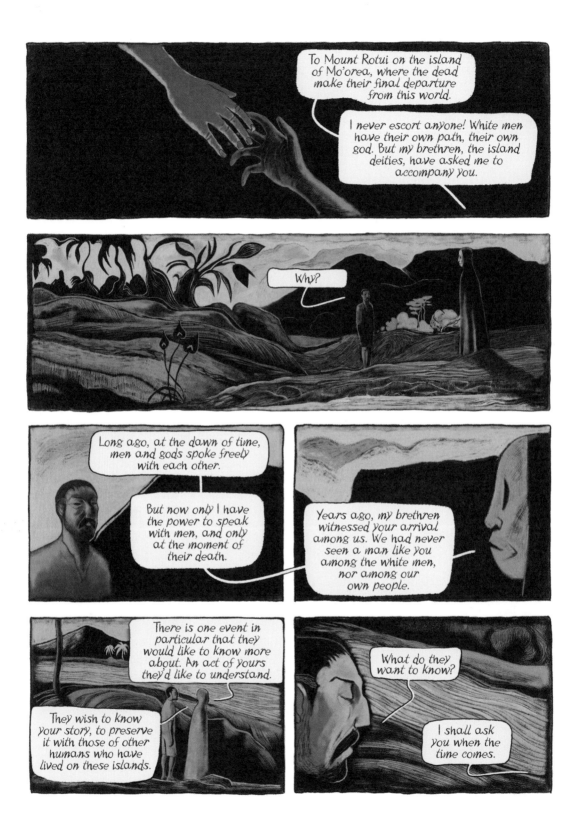

# 2
# Te po

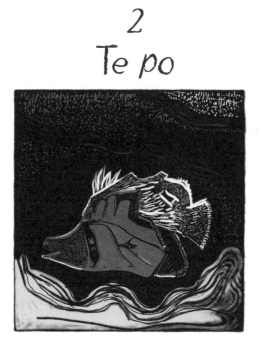

# Everlasting night

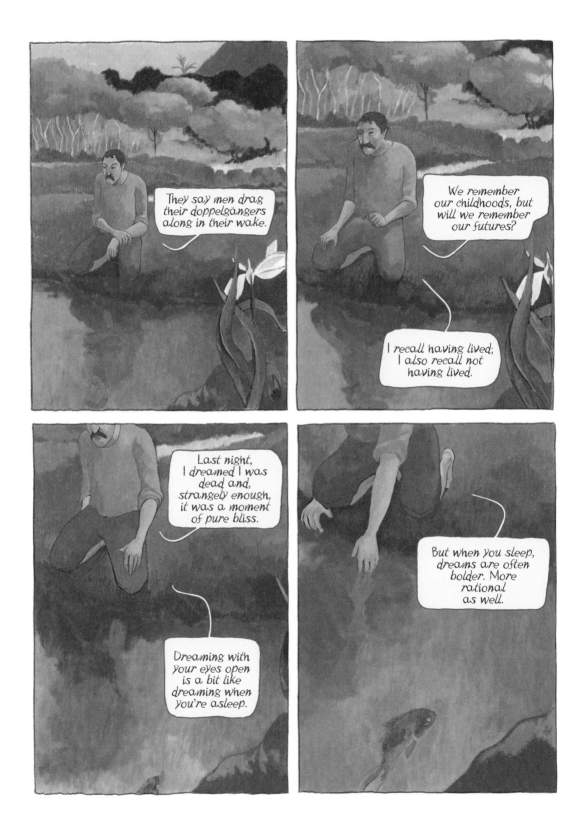

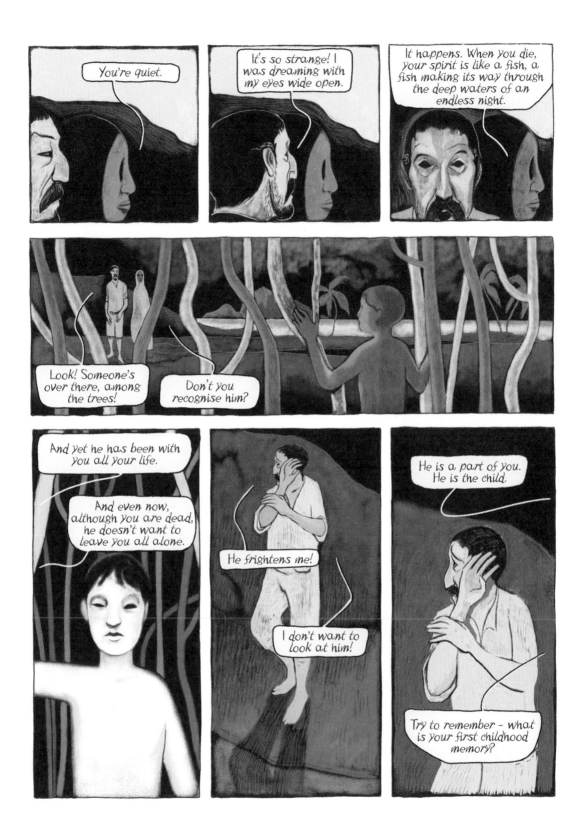

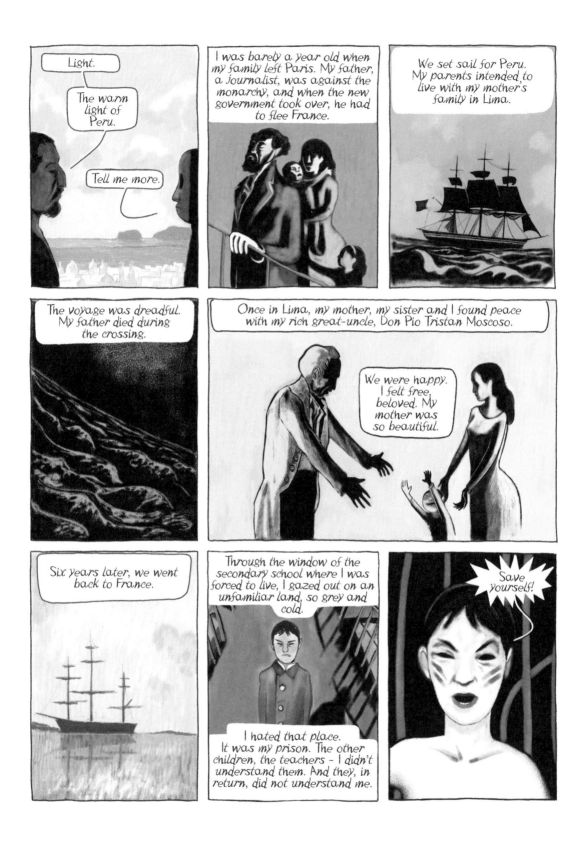

Light.

The warm light of Peru.

Tell me more.

I was barely a year old when my family left Paris. My father, a journalist, was against the monarchy, and when the new government took over, he had to flee France.

We set sail for Peru. My parents intended to live with my mother's family in Lima.

The voyage was dreadful. My father died during the crossing.

Once in Lima, my mother, my sister and I found peace with my rich great-uncle, Don Pio Tristan Moscoso.

We were happy. I felt free, beloved. My mother was so beautiful.

Six years later, we went back to France.

Through the window of the secondary school where I was forced to live, I gazed out on an unfamiliar land, so grey and cold.

I hated that place. It was my prison. The other children, the teachers - I didn't understand them. And they, in return, did not understand me.

Save yourself!

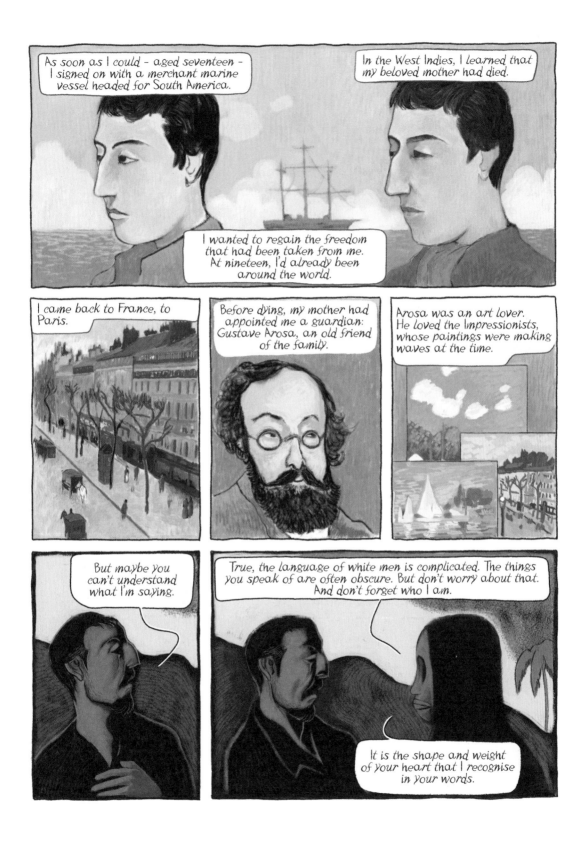

As soon as I could - aged seventeen - I signed on with a merchant marine vessel headed for South America.

In the West Indies, I learned that my beloved mother had died.

I wanted to regain the freedom that had been taken from me. At nineteen, I'd already been around the world.

I came back to France, to Paris.

Before dying, my mother had appointed me a guardian: Gustave Arosa, an old friend of the family.

Arosa was an art lover. He loved the Impressionists, whose paintings were making waves at the time.

But maybe you can't understand what I'm saying.

True, the language of white men is complicated. The things you speak of are often obscure. But don't worry about that. And don't forget who I am.

It is the shape and weight of your heart that I recognise in your words.

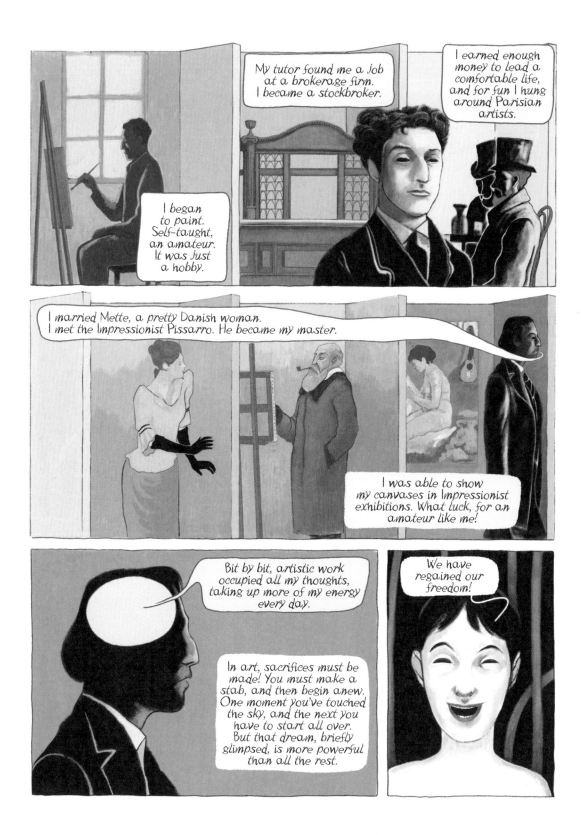

My tutor found me a job at a brokerage firm. I became a stockbroker.

I earned enough money to lead a comfortable life, and for fun I hung around Parisian artists.

I began to paint. Self-taught, an amateur. It was just a hobby.

I married Mette, a pretty Danish woman. I met the Impressionist Pissarro. He became my master.

I was able to show my canvases in Impressionist exhibitions. What luck, for an amateur like me!

Bit by bit, artistic work occupied all my thoughts, taking up more of my energy every day.

In art, sacrifices must be made! You must make a stab, and then begin anew. One moment you've touched the sky, and the next you have to start all over. But that dream, briefly glimpsed, is more powerful than all the rest.

We have regained our freedom!

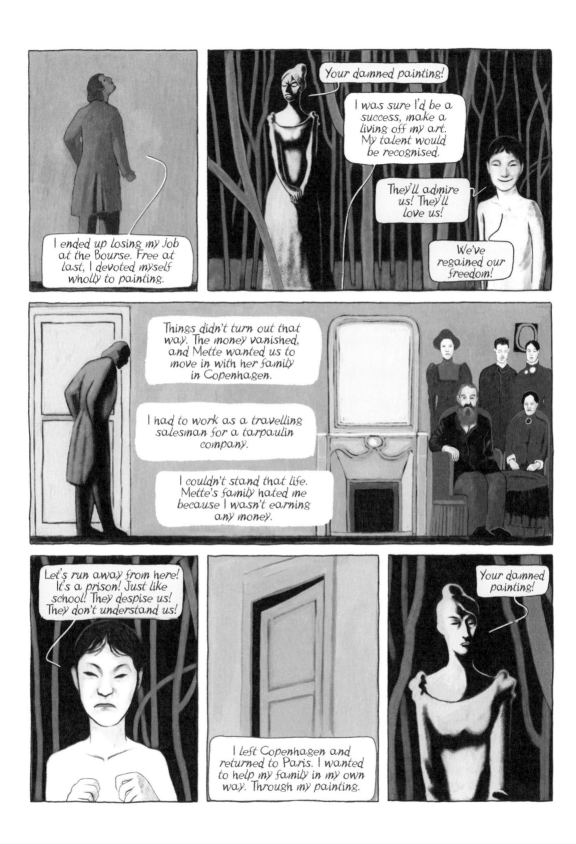

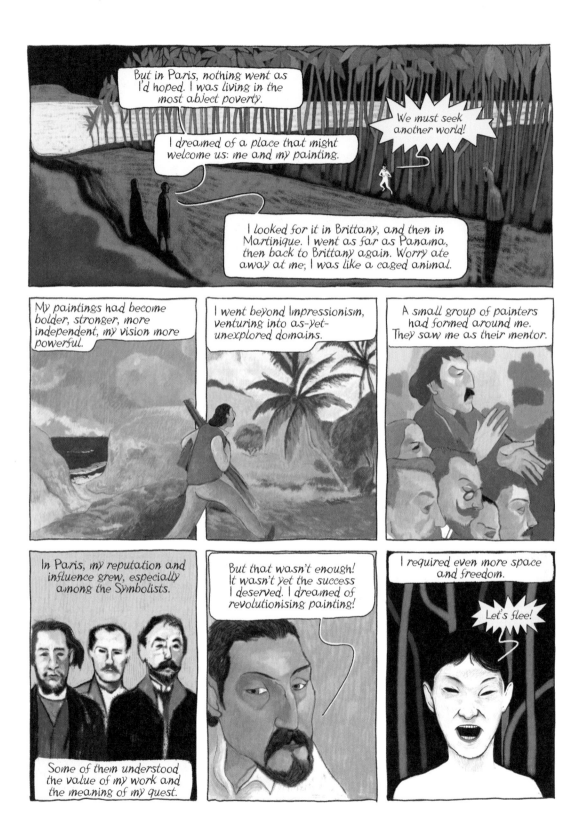

But in Paris, nothing went as I'd hoped. I was living in the most abject poverty.

We must seek another world!

I dreamed of a place that might welcome us: me and my painting.

I looked for it in Brittany, and then in Martinique. I went as far as Panama, then back to Brittany again. Worry ate away at me; I was like a caged animal.

My paintings had become bolder, stronger, more independent, my vision more powerful.

I went beyond Impressionism, venturing into as-yet-unexplored domains.

A small group of painters had formed around me. They saw me as their mentor.

In Paris, my reputation and influence grew, especially among the Symbolists.

Some of them understood the value of my work and the meaning of my quest.

But that wasn't enough! It wasn't yet the success I deserved. I dreamed of revolutionising painting!

I required even more space and freedom.

Let's flee!

Among painters, there was one in particular who appreciated my work. His name was Vincent van Gogh.

Though different, Vincent and I shared the same vision, the same hope.

Together, we dreamed of a studio in the tropics, a community of artists living and working together, far away from Europe!

But things didn't turn out that way. In the end, I left alone.

Far from this mediocre society where small men triumphed!

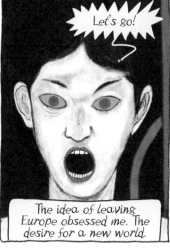

Let's go!

The idea of leaving Europe obsessed me. The desire for a new world.

In 1891, I managed to set my plans in motion. In Marseilles, I boarded a ship for Tahiti.

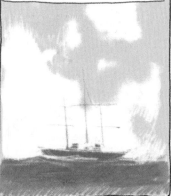

The time has come, for us as well, to take to the seas.

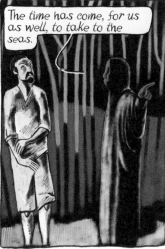

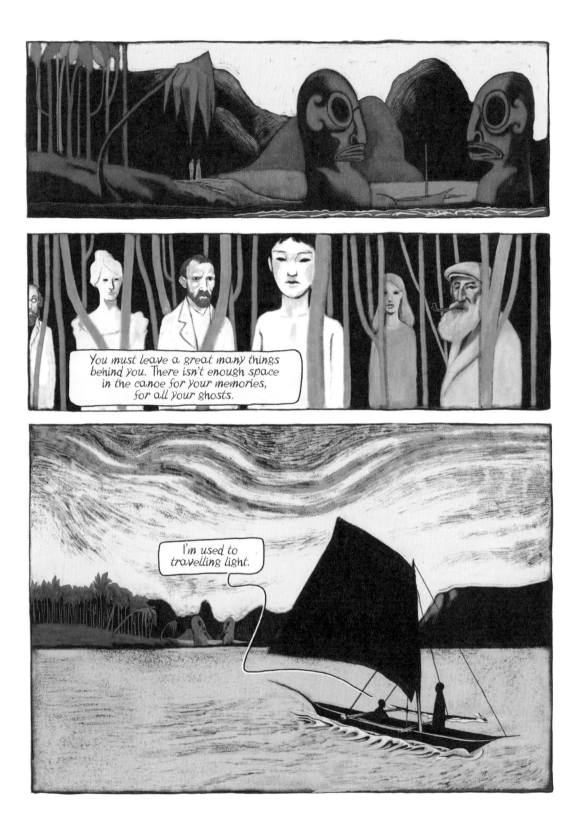

# 3
# Te nave nave fenua

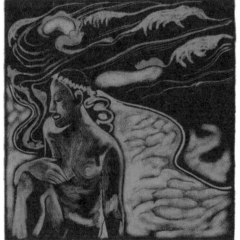

# The delightful land

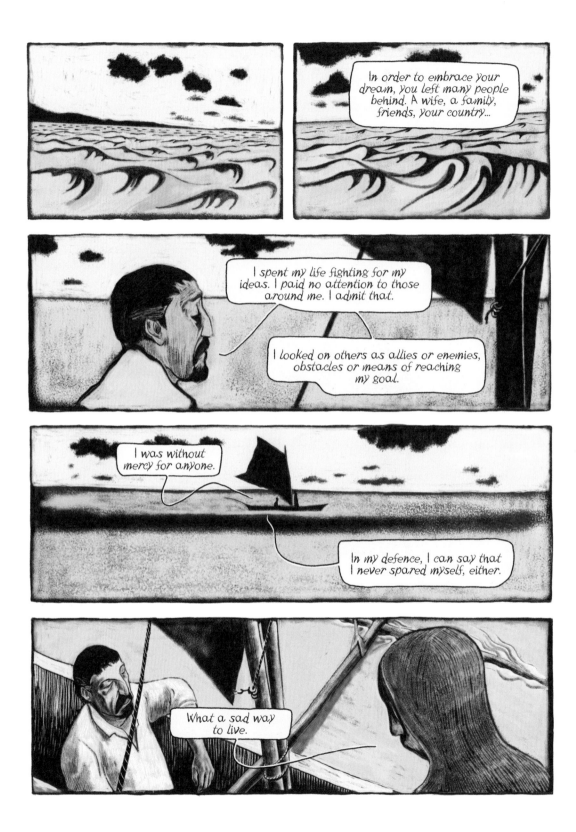

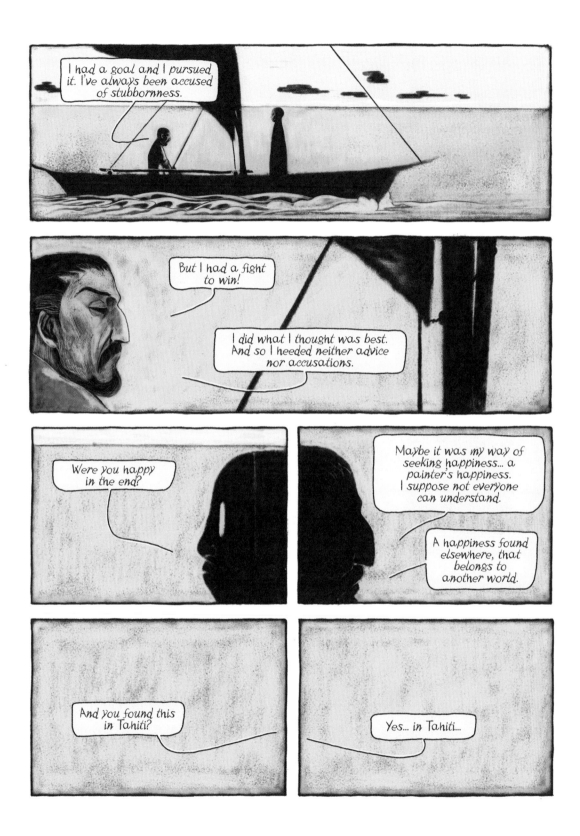

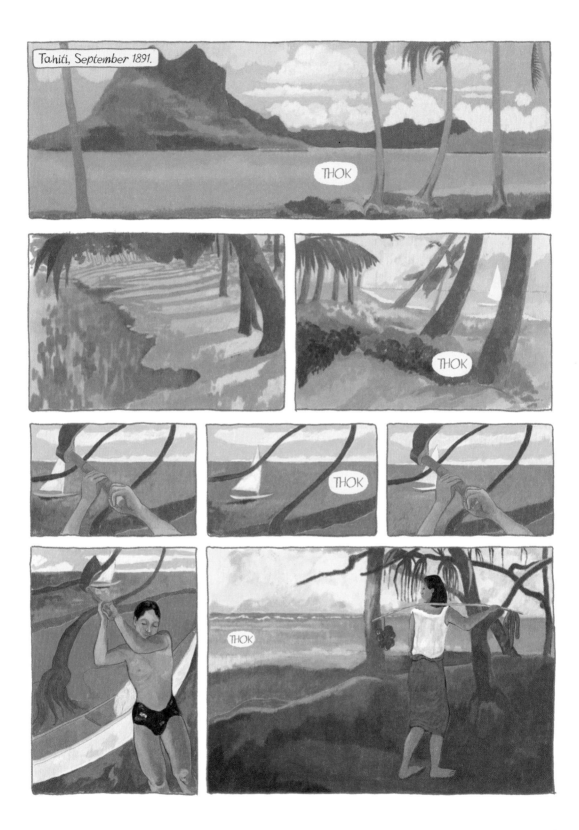

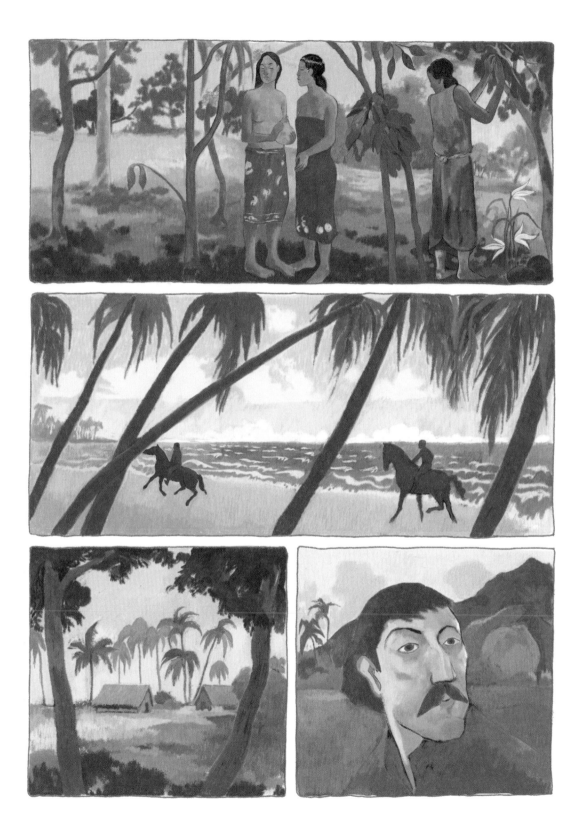

Today, I was in the district of Mataiea, forty-five kilometres from Papeete.

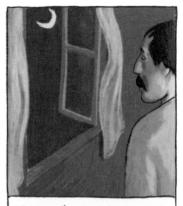

At last I've found traces of the distant, mysterious past I've been seeking.

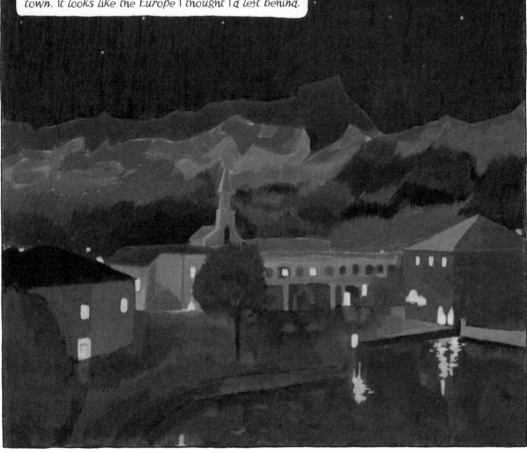

I lived in Papeete for too long. Papeete is a colonists' town. It looks like the Europe I thought I'd left behind.

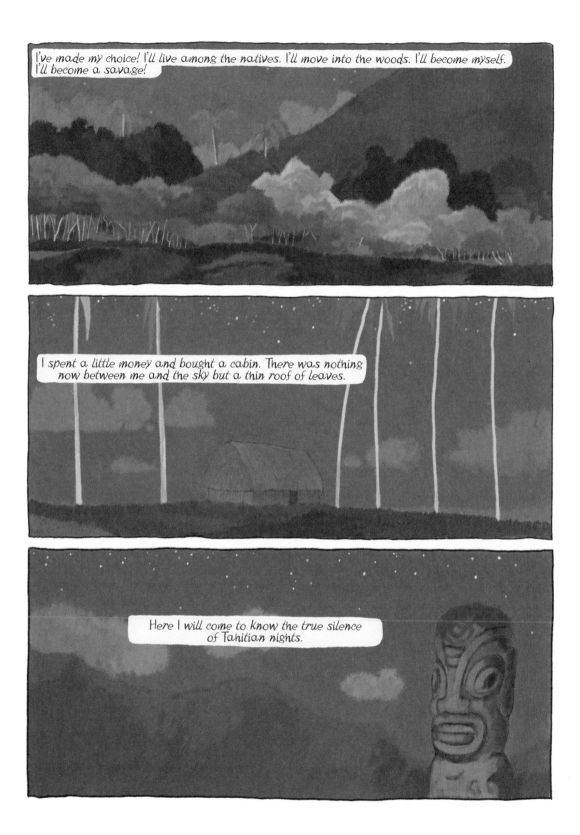

I've made my choice! I'll live among the natives. I'll move into the woods. I'll become myself. I'll become a savage!

I spent a little money and bought a cabin. There was nothing now between me and the sky but a thin roof of leaves.

Here I will come to know the true silence of Tahitian nights.

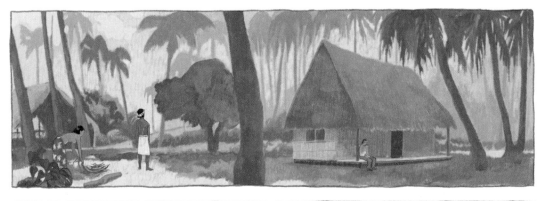

How hungry I am! Just two days, and I'm out of supplies. What a blow!

I thought I could buy food from the village. But that isn't the case.

To eat around here, you have to know how to climb a tree.

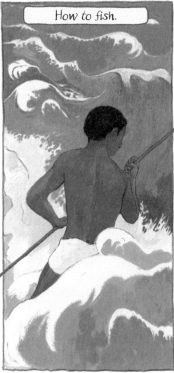

How to fish.

How to hunt in the mountains.

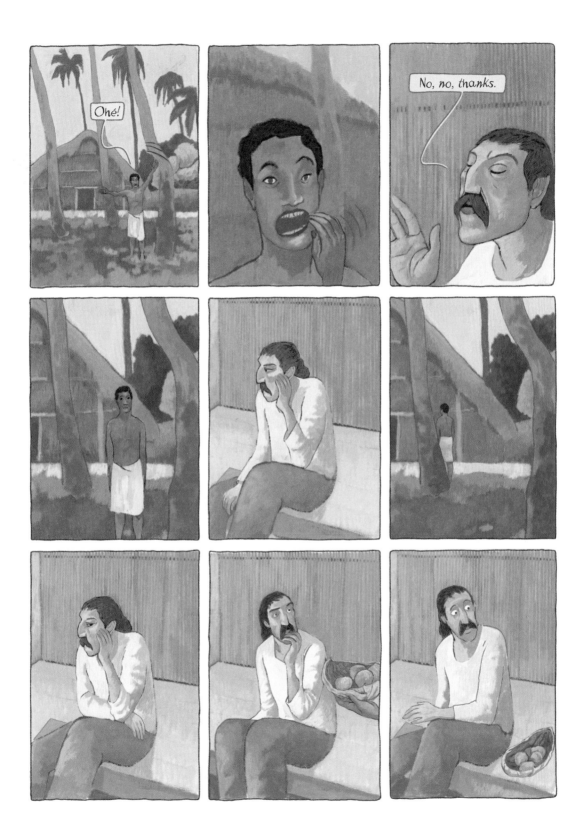

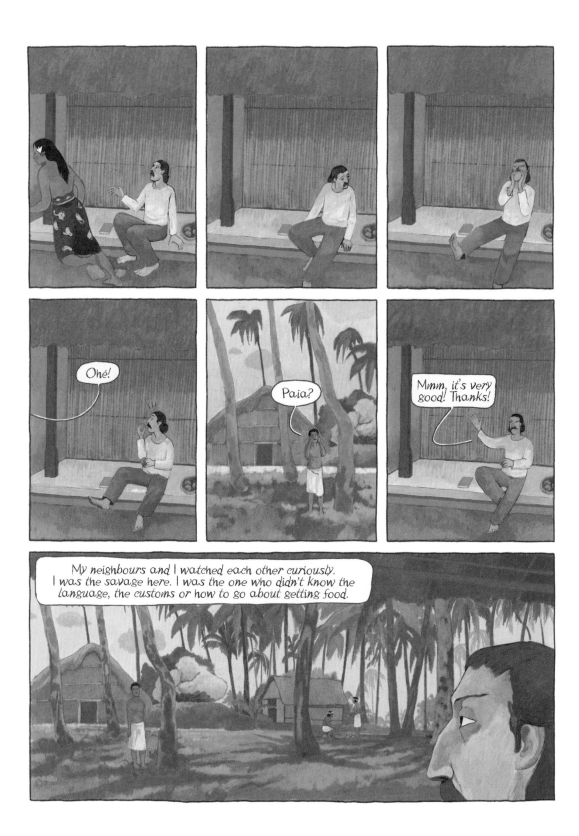

Ohé!

Paia?

Mmm, it's very good! Thanks!

My neighbours and I watched each other curiously. I was the savage here. I was the one who didn't know the language, the customs or how to go about getting food.

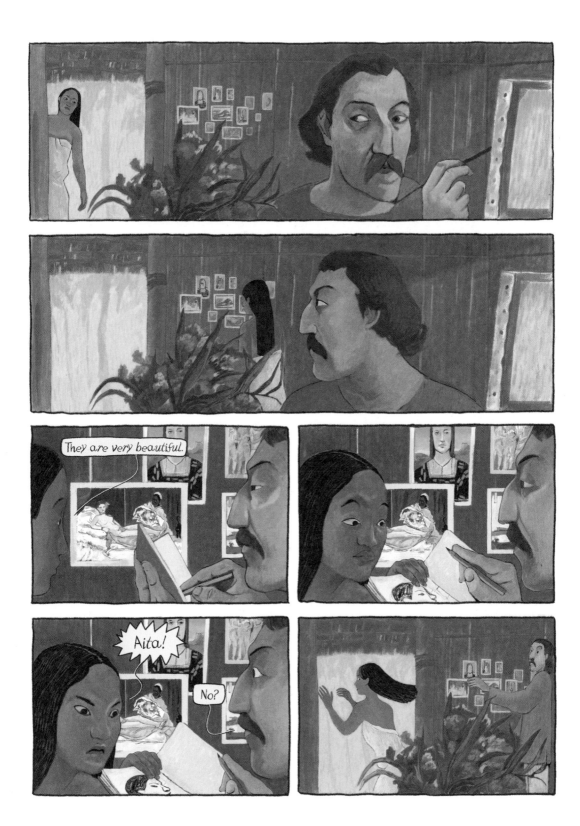

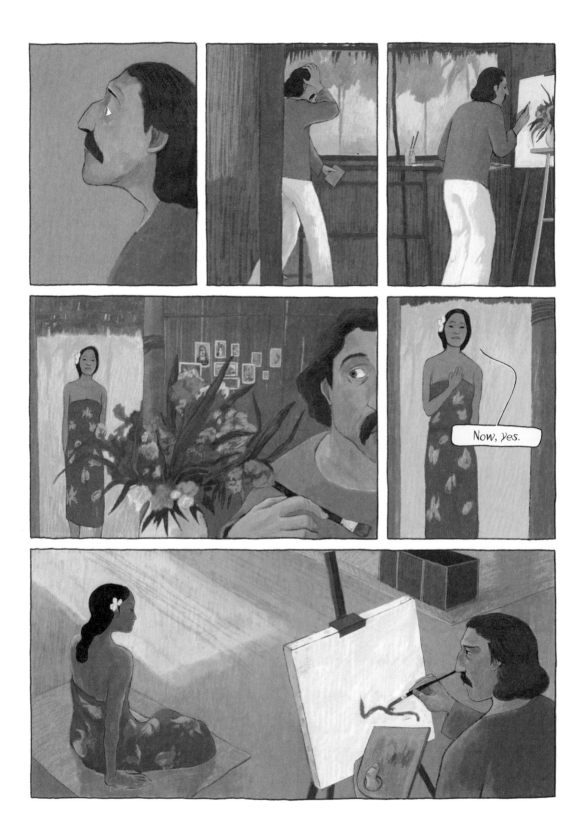

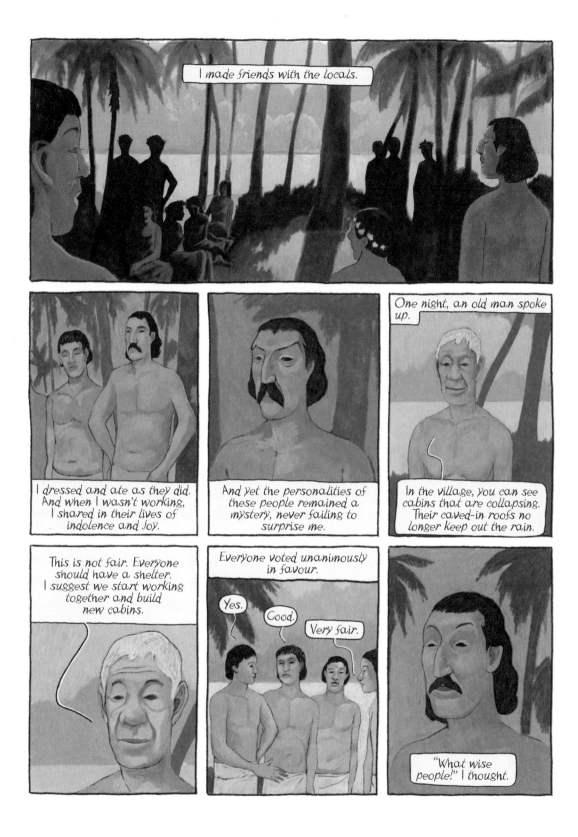

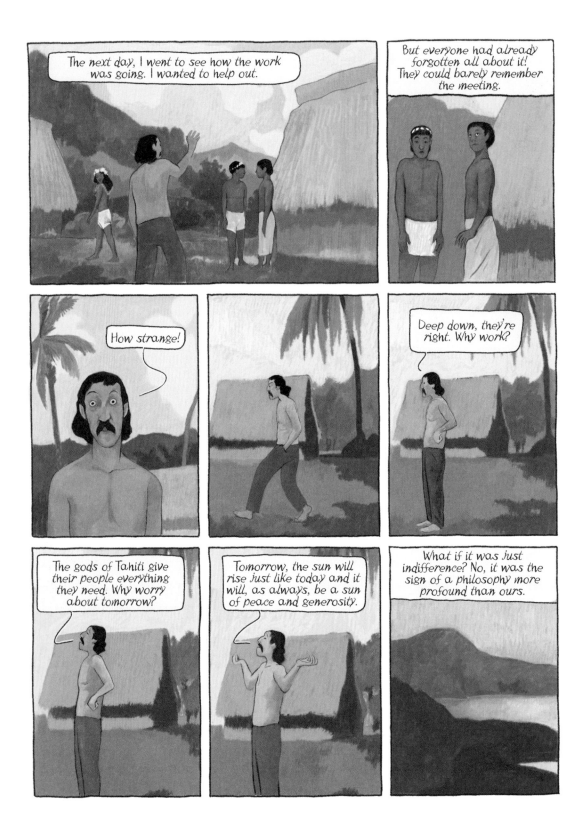

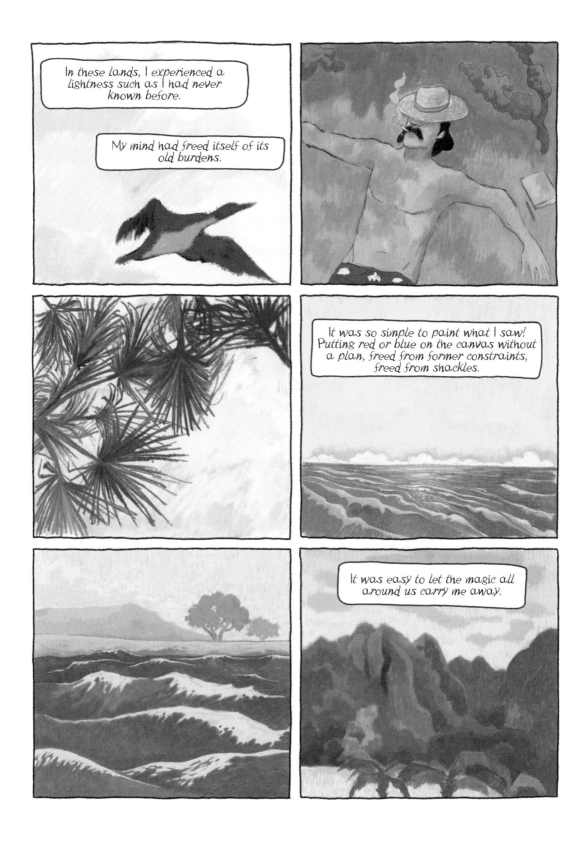

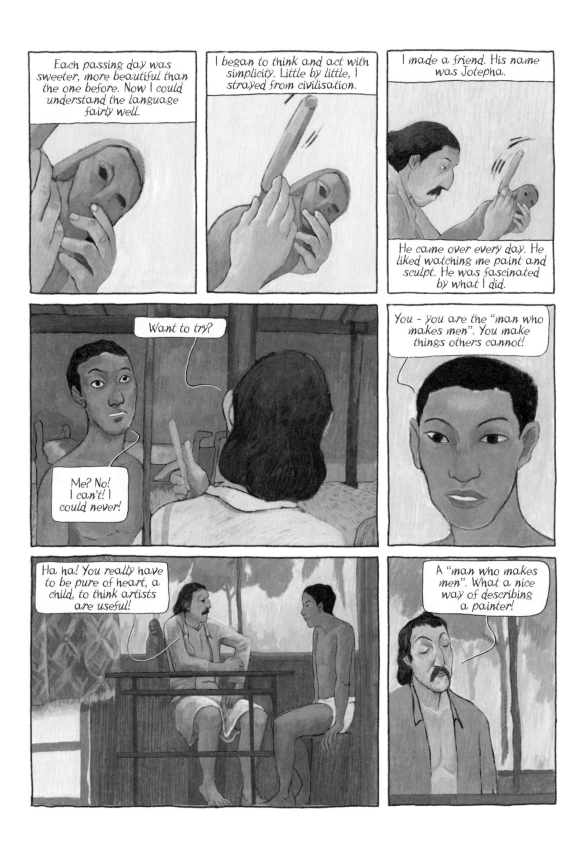

Each passing day was sweeter, more beautiful than the one before. Now I could understand the language fairly well.

I began to think and act with simplicity. Little by little, I strayed from civilisation.

I made a friend. His name was Jotepha.

He came over every day. He liked watching me paint and sculpt. He was fascinated by what I did.

Want to try?

Me? No! I can't! I could never!

You - you are the "man who makes men". You make things others cannot!

Ha ha! You really have to be pure of heart, a child, to think artists are useful!

A "man who makes men". What a nice way of describing a painter!

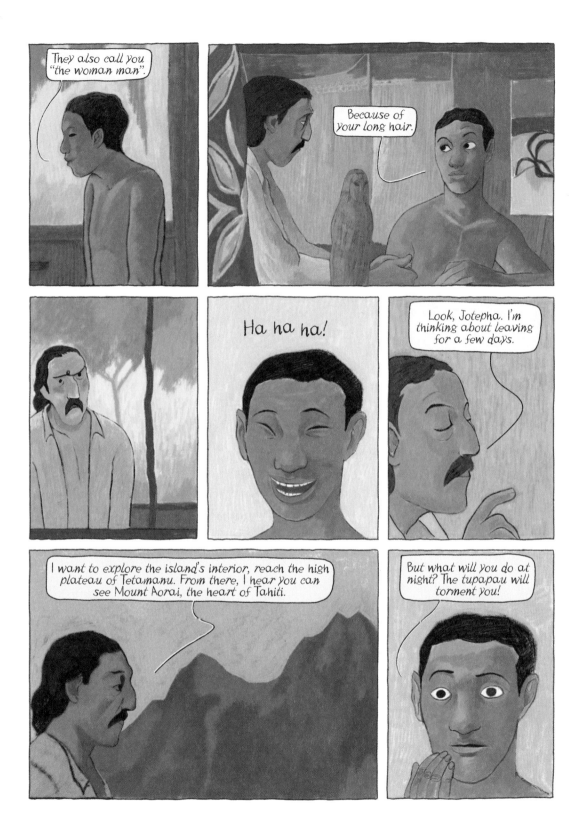

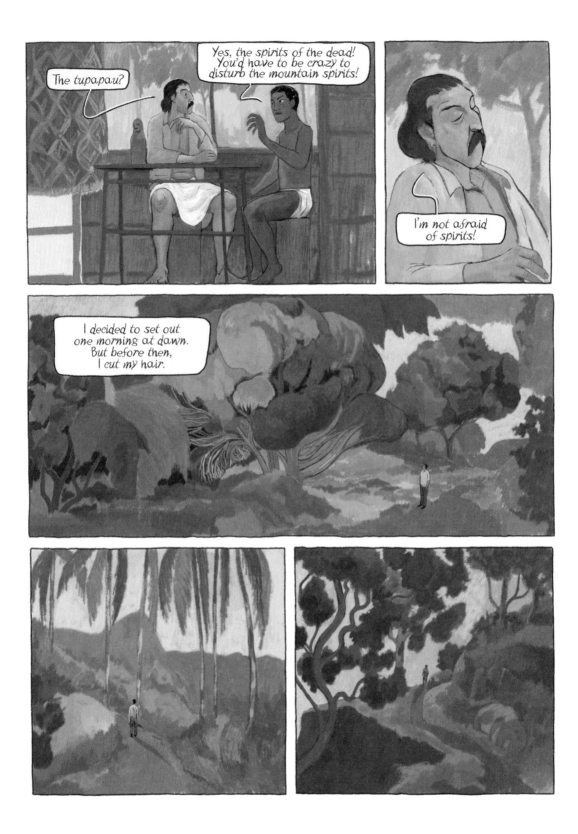

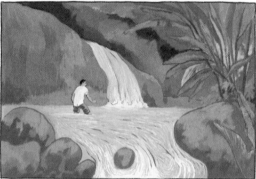

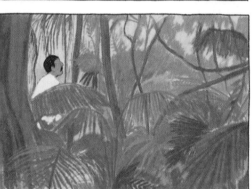
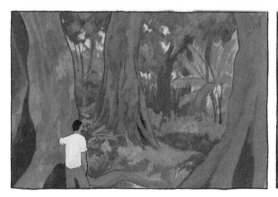
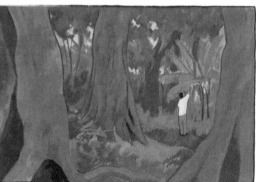

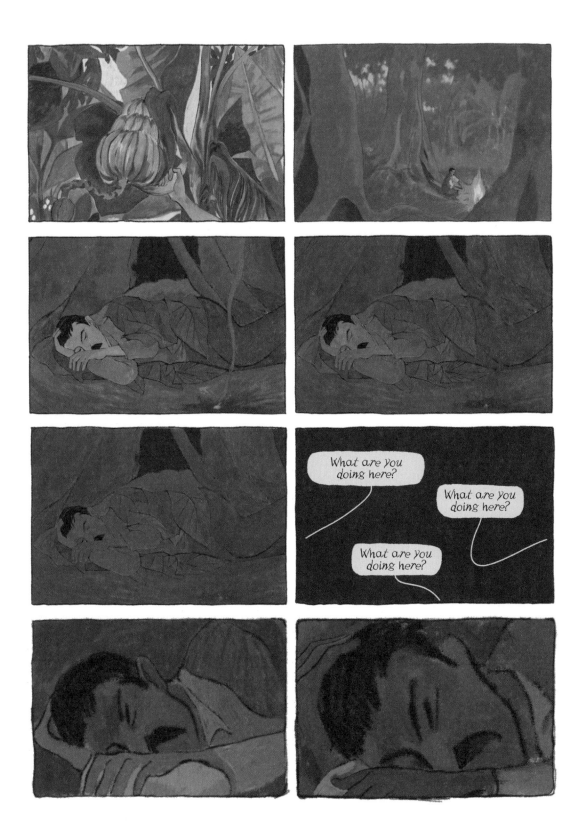

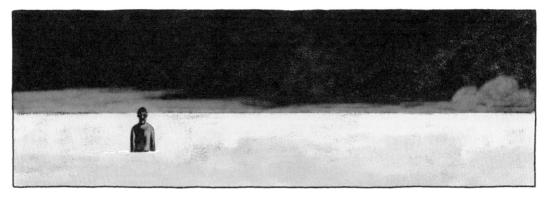

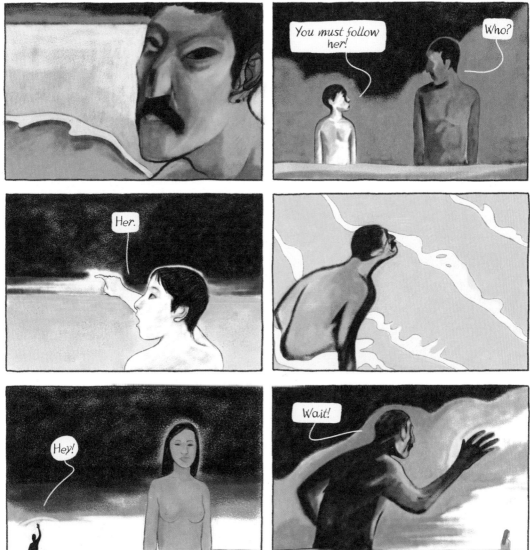

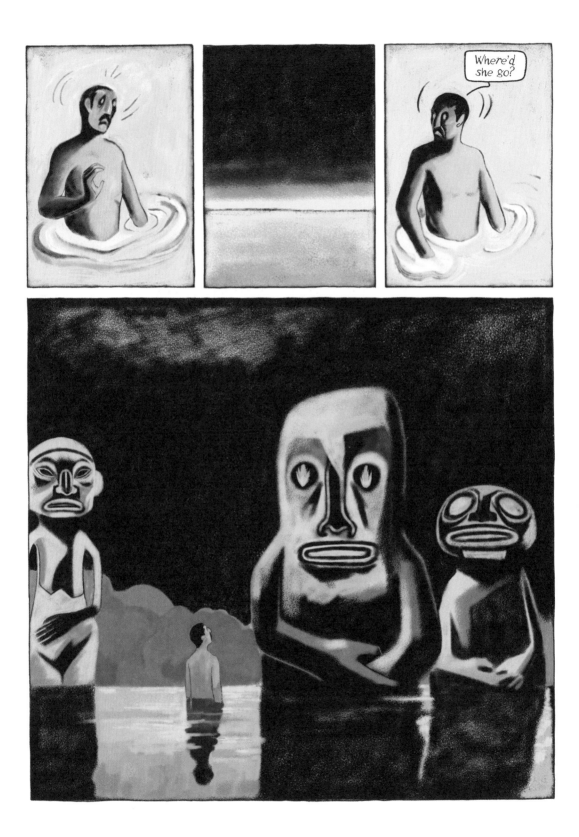

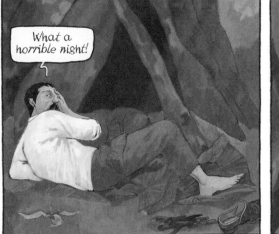

What a horrible night!

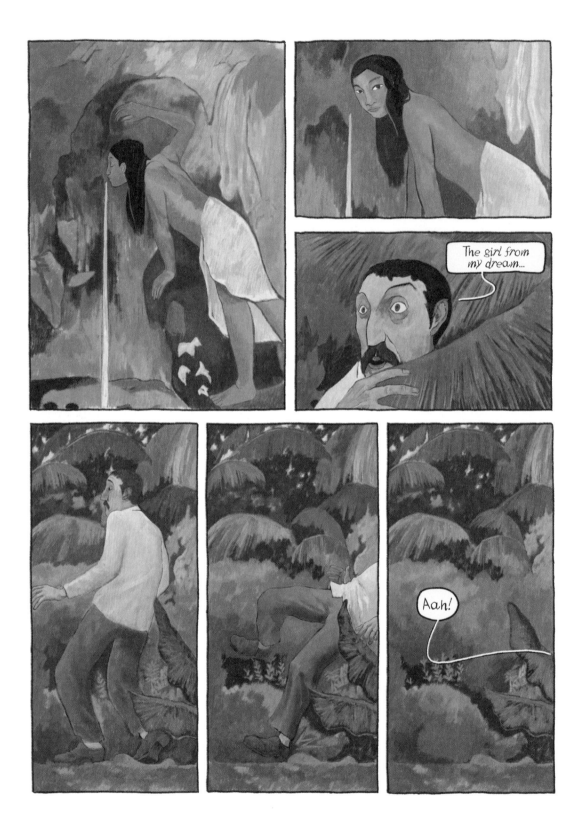

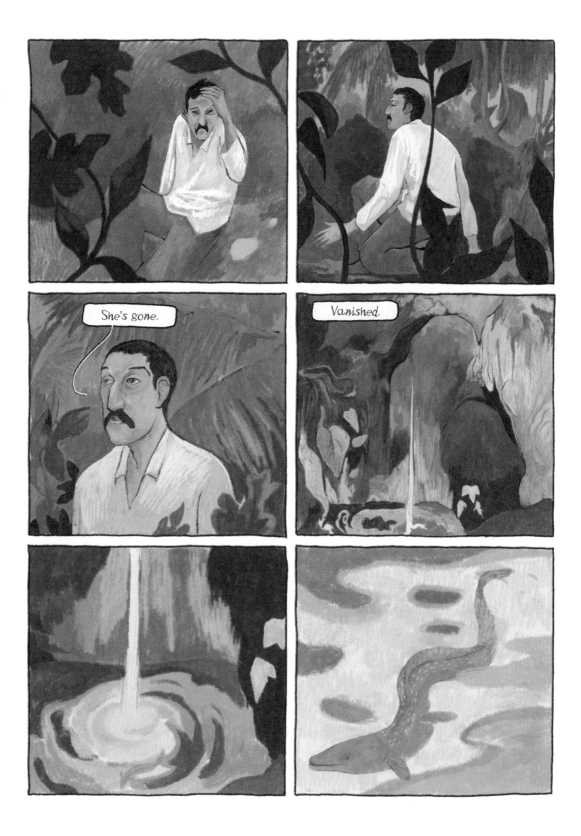

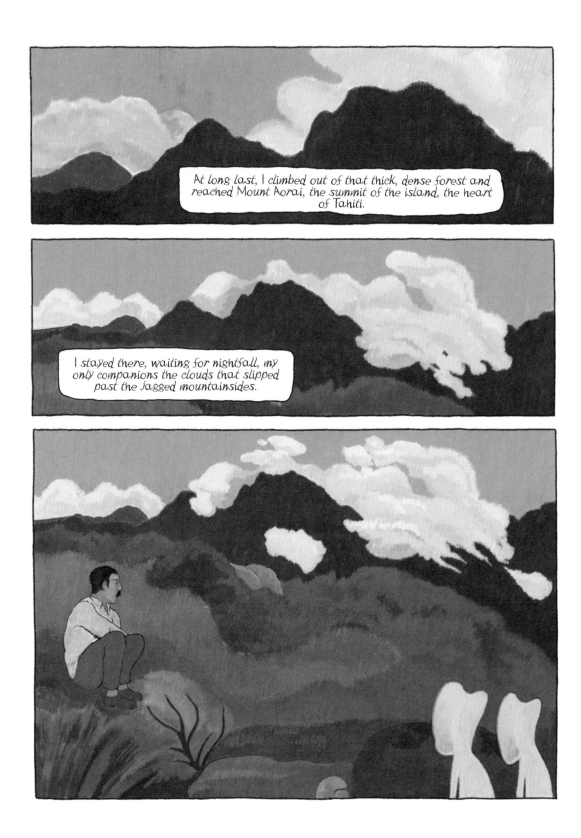

At long last, I climbed out of that thick, dense forest and reached Mount Aorai, the summit of the island, the heart of Tahiti.

I stayed there, waiting for nightfall, my only companions the clouds that slipped past the jagged mountainsides.

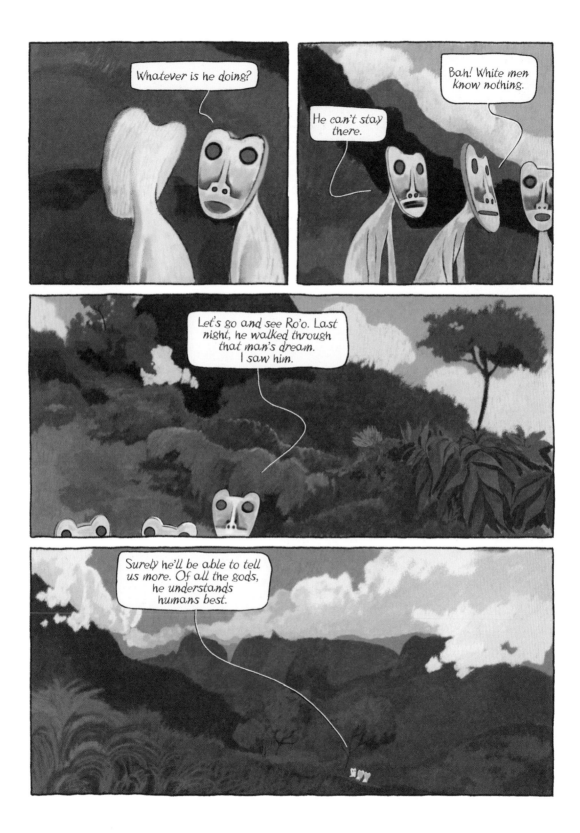

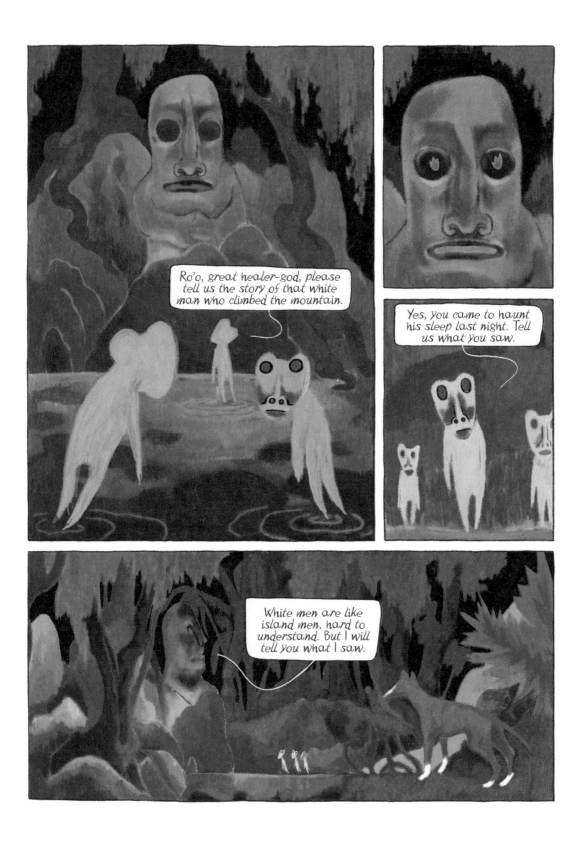

Ro'o, great healer-god, please tell us the story of that white man who climbed the mountain.

Yes, you came to haunt his sleep last night. Tell us what you saw.

White men are like island men, hard to understand. But I will tell you what I saw.

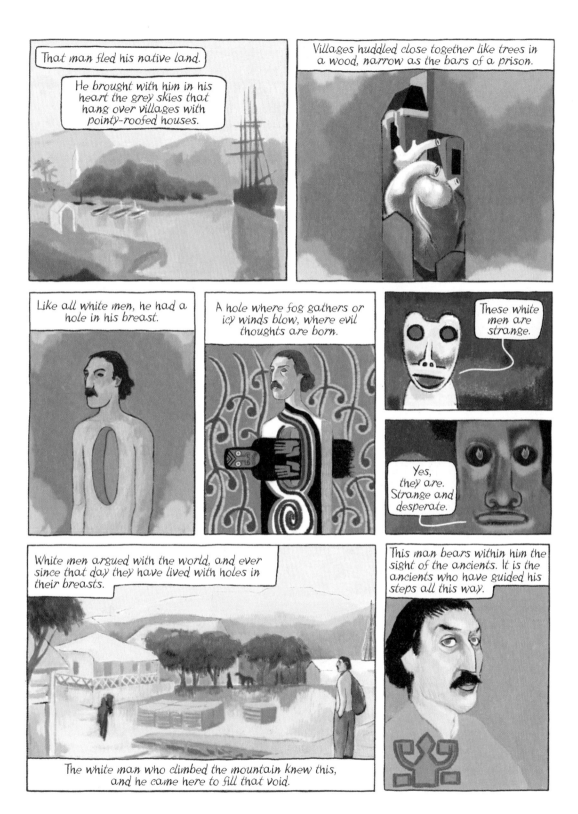

That man fled his native land.

He brought with him in his heart the grey skies that hang over villages with pointy-roofed houses.

Villages huddled close together like trees in a wood, narrow as the bars of a prison.

Like all white men, he had a hole in his breast.

A hole where fog gathers or icy winds blow, where evil thoughts are born.

These white men are strange.

Yes, they are. Strange and desperate.

White men argued with the world, and ever since that day they have lived with holes in their breasts.

The white man who climbed the mountain knew this, and he came here to fill that void.

This man bears within him the sight of the ancients. It is the ancients who have guided his steps all this way.

I've seen those figures before! I recognise them.

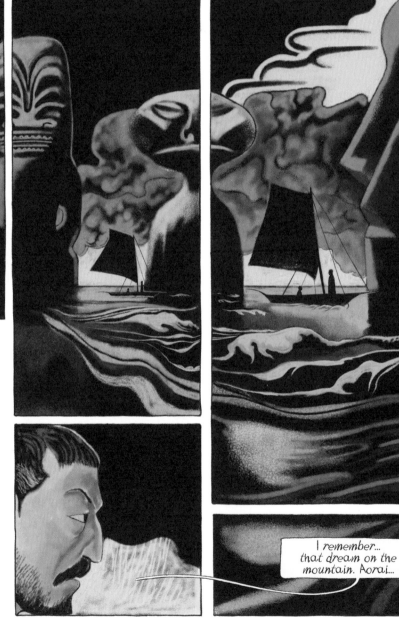

I remember... that dream on the mountain. Aorai...

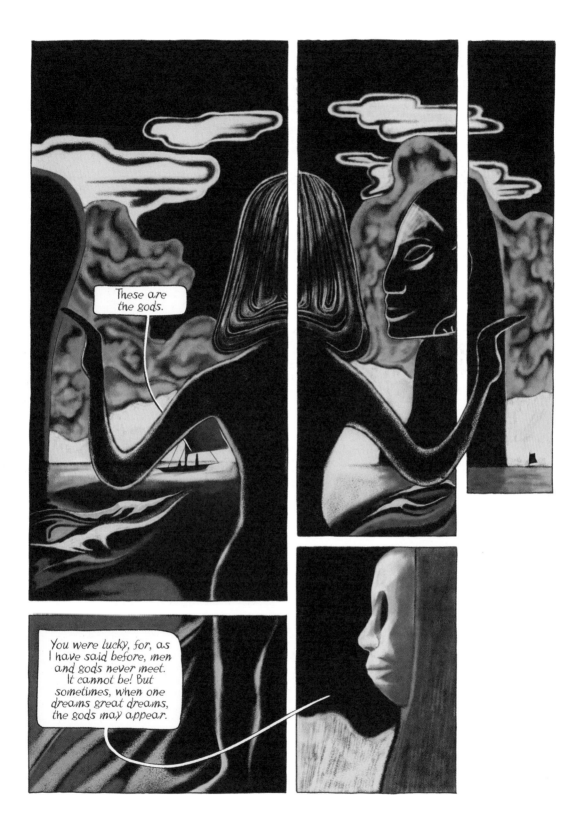

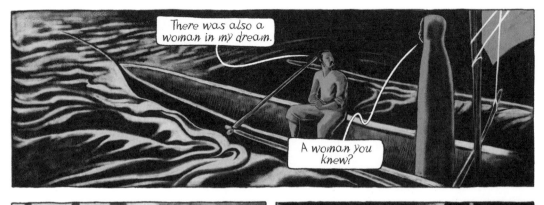

There was also a woman in my dream.

A woman you knew?

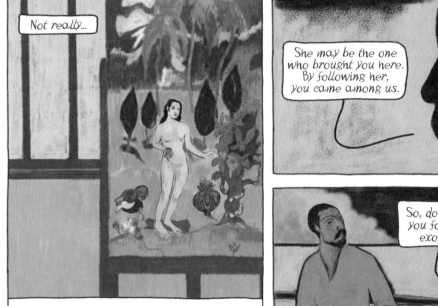

Not really...

But a year ago, before leaving for Tahiti, I did a painting... depicting an exotic Eve. In a way, that woman reminds me of her.

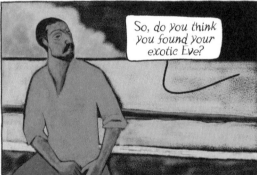

She may be the one who brought you here. By following her, you came among us.

So, do you think you found your exotic Eve?

Yes, I suppose so... Her name was Teura.

# 4
## Te atua

## The gods

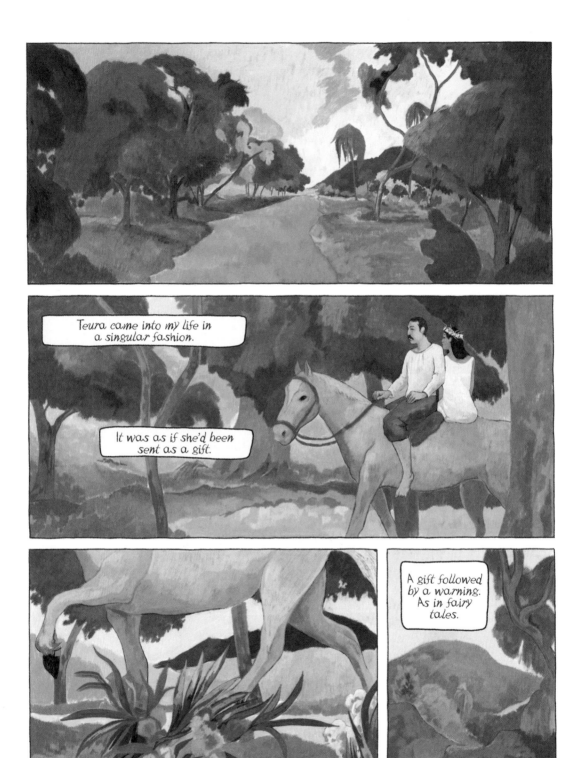

Teura came into my life in a singular fashion.

It was as if she'd been sent as a gift.

A gift followed by a warning. As in fairy tales.

In the small village of Fa'aone, a native invited me to his hut.

Hey! Man who makes men, come and eat with us.

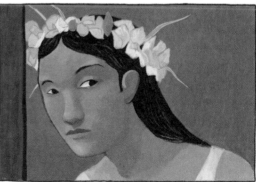

My first meeting with Teura occurred on one of my many explorations of the island. A gendarme who lived in Taravao had lent me his horse. My first idea was to head for the east coast, where few Europeans went.

PAPEETE

AORAI

FA'AONE

MATAIEA

TARAVAO

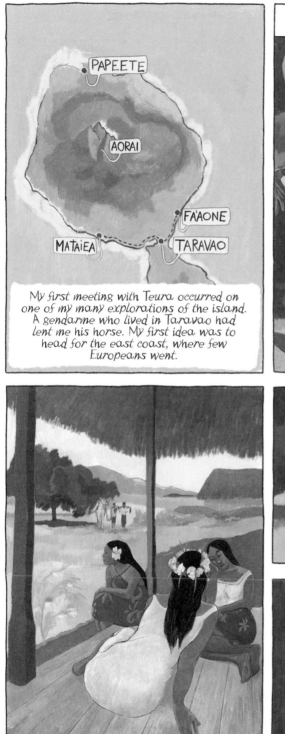

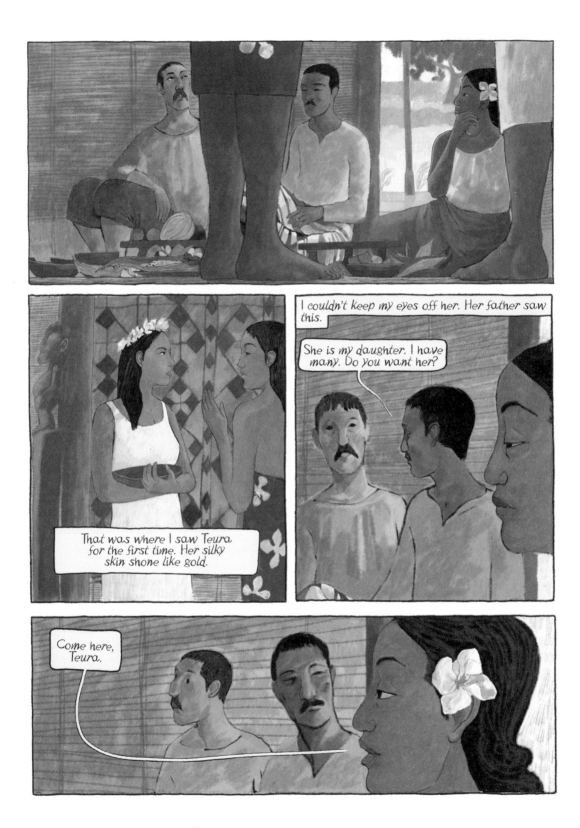

I couldn't keep my eyes off her. Her father saw this.

She is *my* daughter. I have many. Do you want her?

That was where I saw Teura for the first time. Her silky skin shone like gold.

Come here, Teura.

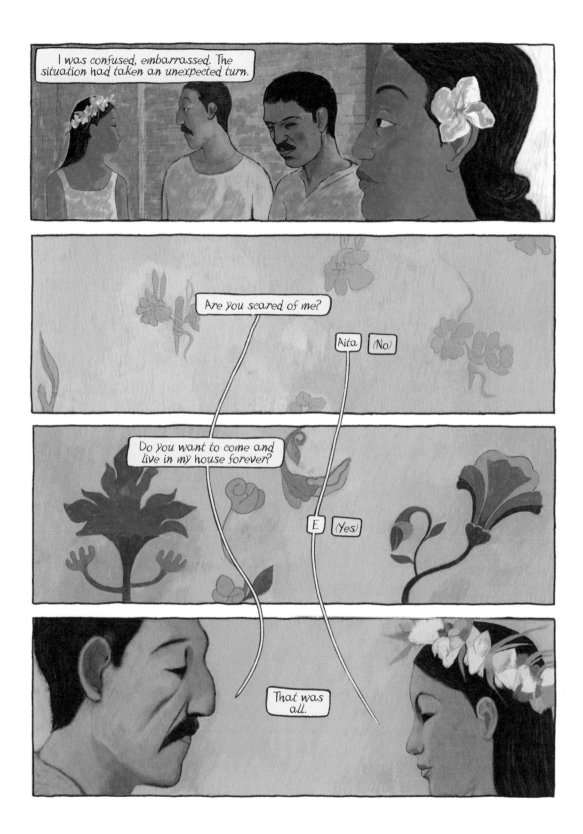

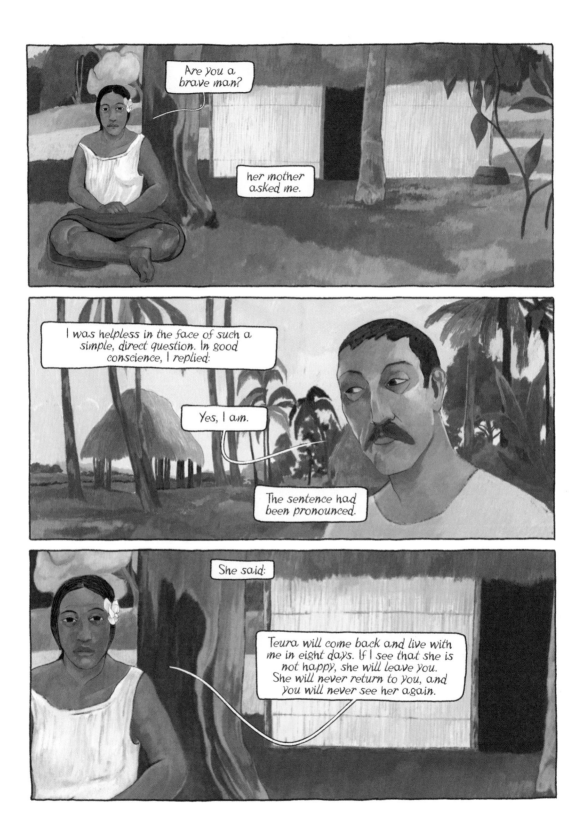

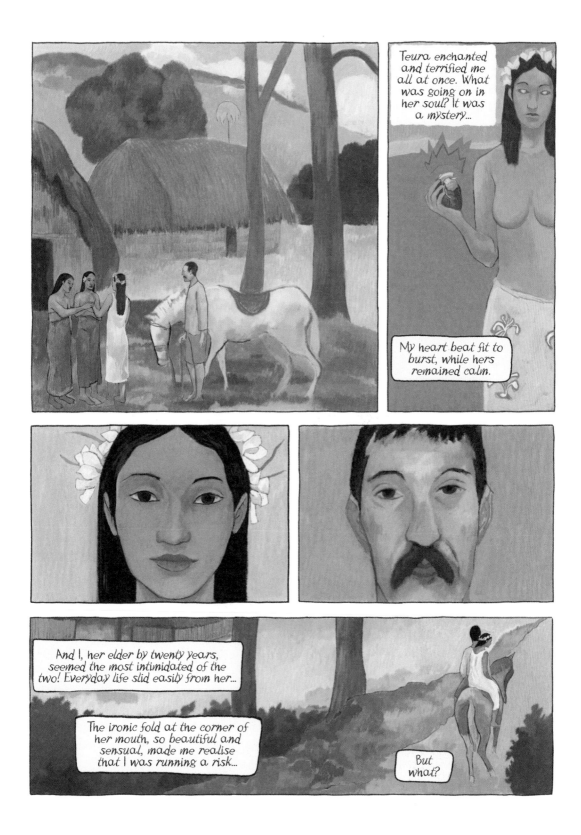

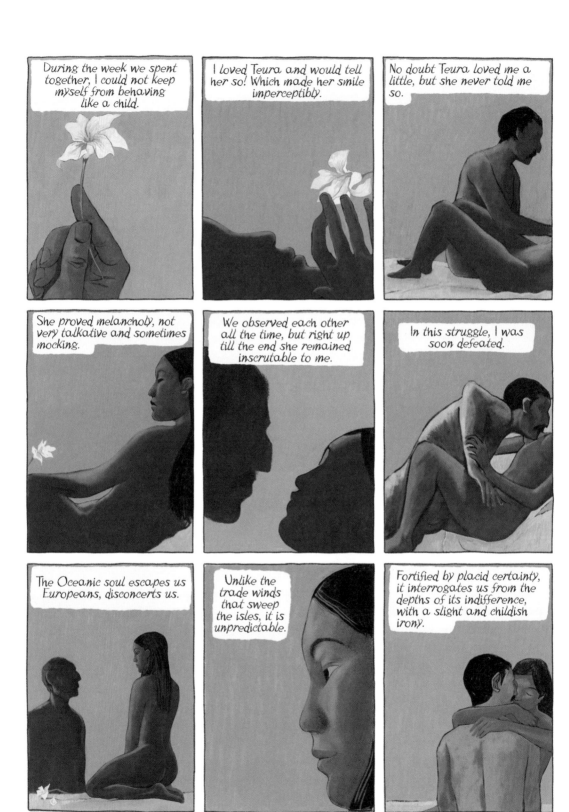

During the week we spent together, I could not keep myself from behaving like a child.

I loved Teura and would tell her so! Which made her smile imperceptibly.

No doubt Teura loved me a little, but she never told me so.

She proved melancholy, not very talkative and sometimes mocking.

We observed each other all the time, but right up till the end she remained inscrutable to me.

In this struggle, I was soon defeated.

The Oceanic soul escapes us Europeans, disconcerts us.

Unlike the trade winds that sweep the isles, it is unpredictable.

Fortified by placid certainty, it interrogates us from the depths of its indifference, with a slight and childish irony.

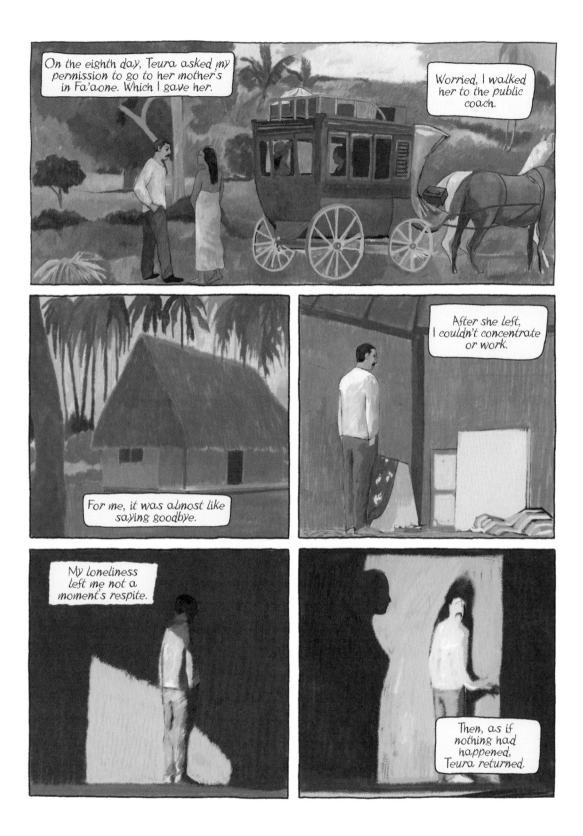

On that day, our happiness began. We were like the first man and the first woman in earthly paradise.

I could no longer keep track of the days, of the hours, of good and evil. We lived immersed in our Tahitian Eden, in a faraway time from before history, before the time of men.

Thanks to Teura, I now had access to many of the island's mysteries that had escaped me till now.

In her twinned soul, which was that of a little girl and an ancient ancestor, I found traces of a distant past.

The gods of long ago, whom the Protestant missionaries believed they'd driven from the islands forever, had in fact hidden deep in the memory of Tahitian women.

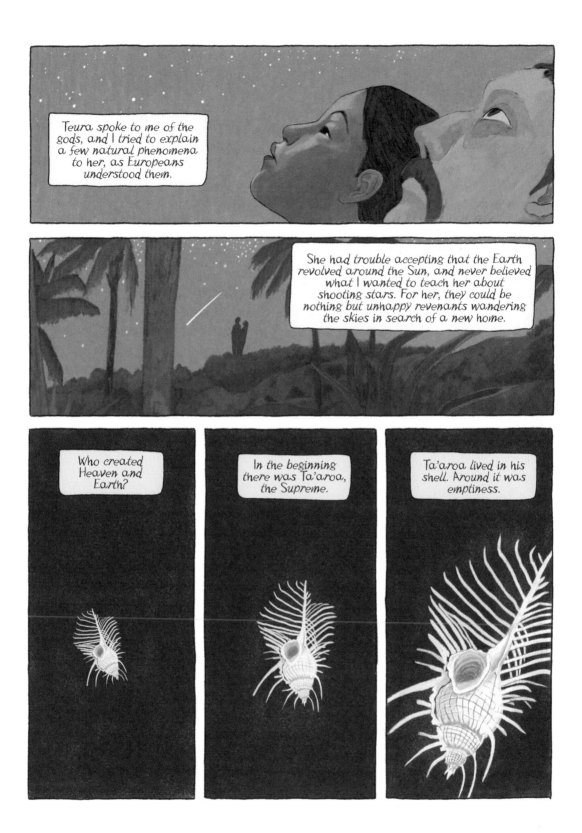

Teura spoke to me of the gods, and I tried to explain a few natural phenomena to her, as Europeans understood them.

She had trouble accepting that the Earth revolved around the Sun, and never believed what I wanted to teach her about shooting stars. For her, they could be nothing but unhappy revenants wandering the skies in search of a new home.

Who created Heaven and Earth?

In the beginning there was Ta'aroa, the Supreme.

Ta'aroa lived in his shell. Around it was emptiness.

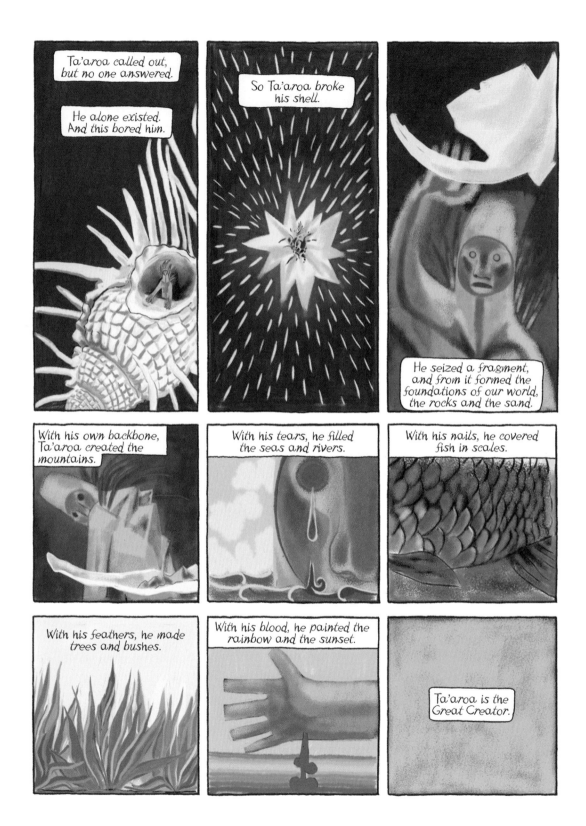

Ta'aroa called out, but no one answered.

He alone existed. And this bored him.

So Ta'aroa broke his shell.

He seized a fragment, and from it formed the foundations of our world, the rocks and the sand.

With his own backbone, Ta'aroa created the mountains.

With his tears, he filled the seas and rivers.

With his nails, he covered fish in scales.

With his feathers, he made trees and bushes.

With his blood, he painted the rainbow and the sunset.

Ta'aroa is the Great Creator.

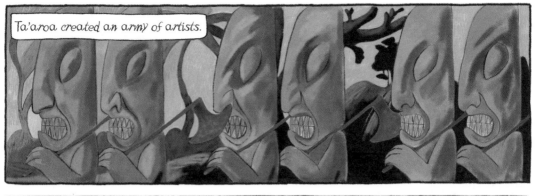

Ta'aroa created an army of artists.

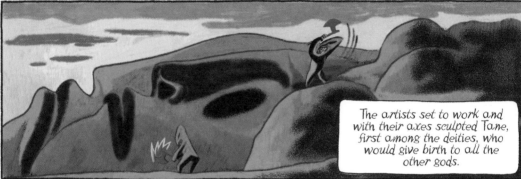

The artists set to work and with their axes sculpted Tane, first among the deities, who would give birth to all the other gods.

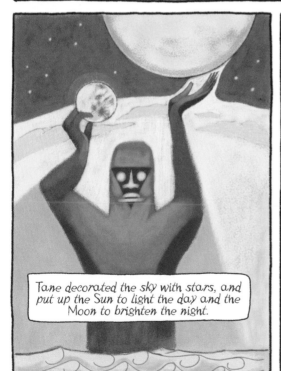

Tane decorated the sky with stars, and put up the Sun to light the day and the Moon to brighten the night.

During this time, Ru, god of the transmigration of souls, carved a gigantic canoe and decided to travel the newly created world.

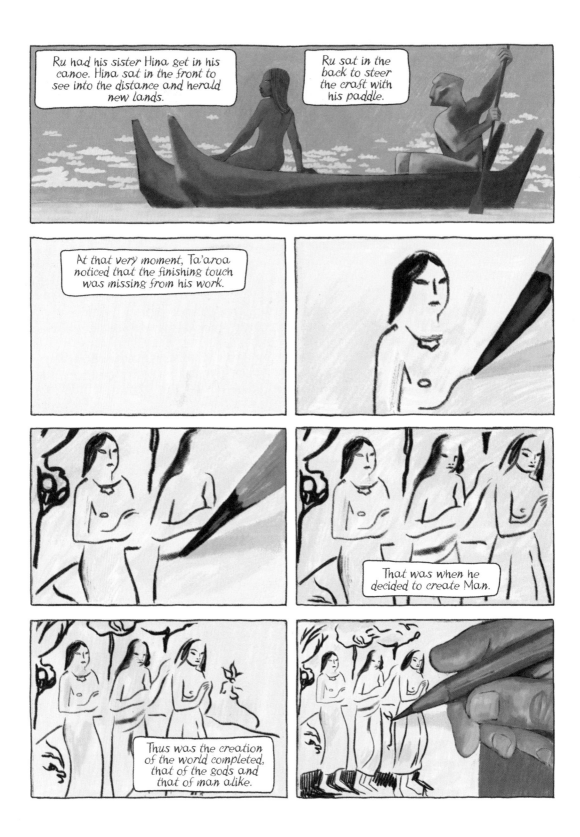

Ru had his sister Hina get in his canoe. Hina sat in the front to see into the distance and herald new lands.

Ru sat in the back to steer the craft with his paddle.

At that very moment, Ta'aroa noticed that the finishing touch was missing from his work.

That was when he decided to create Man.

Thus was the creation of the world completed, that of the gods and that of man alike.

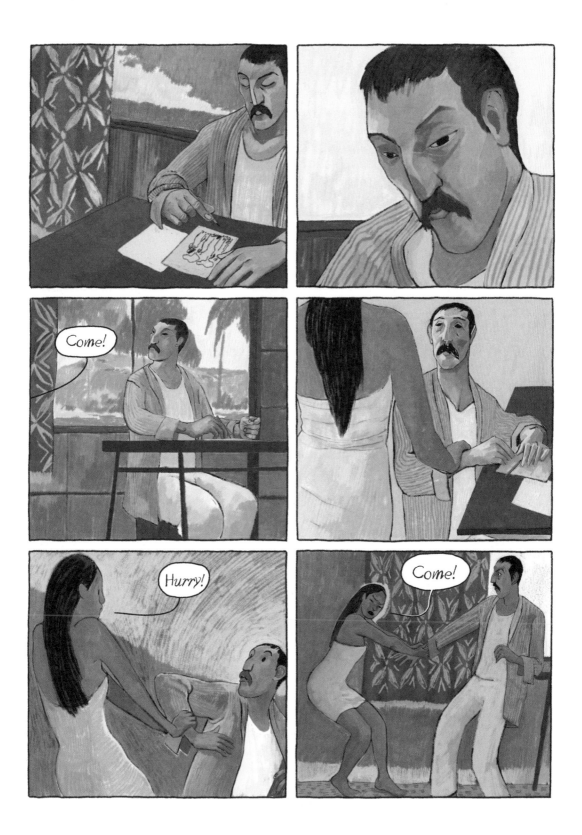

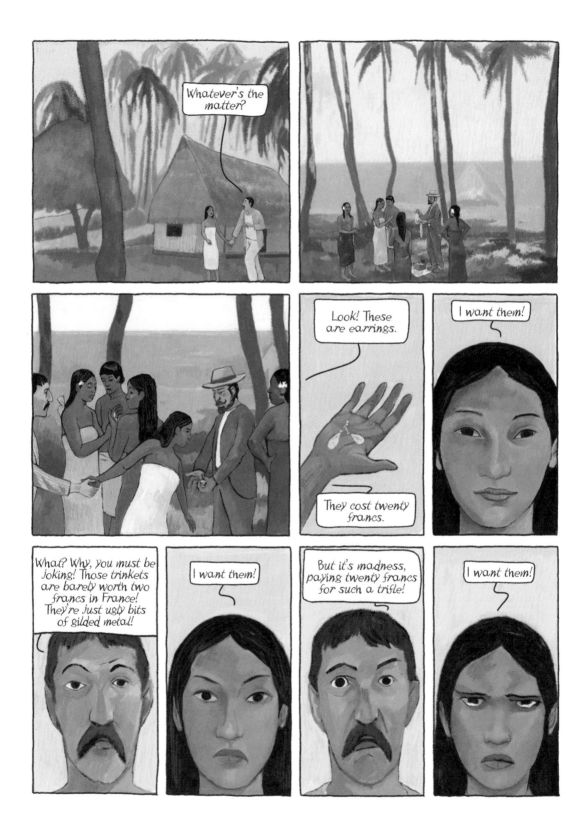

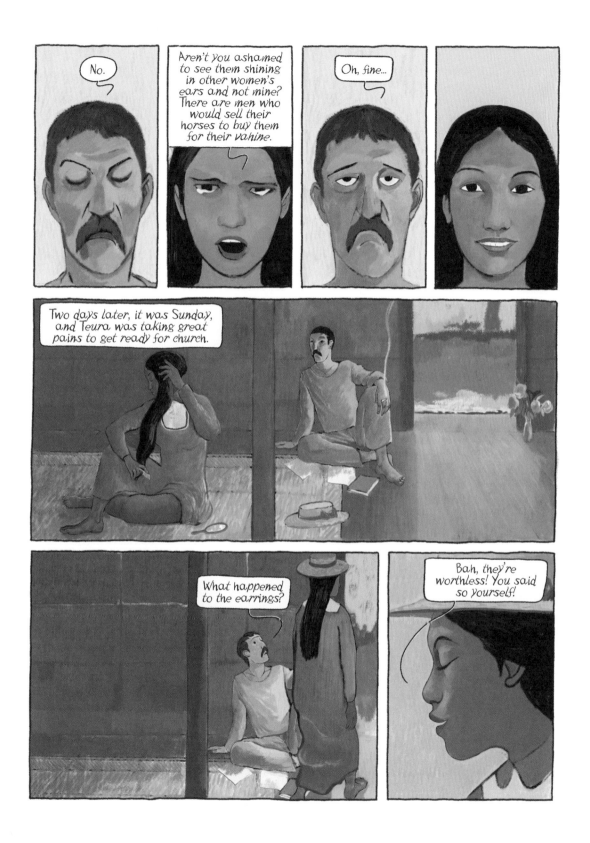

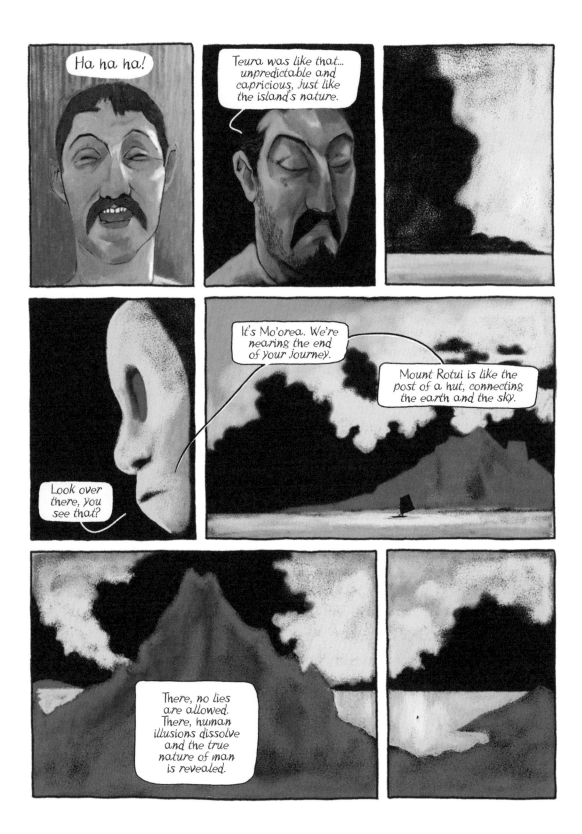

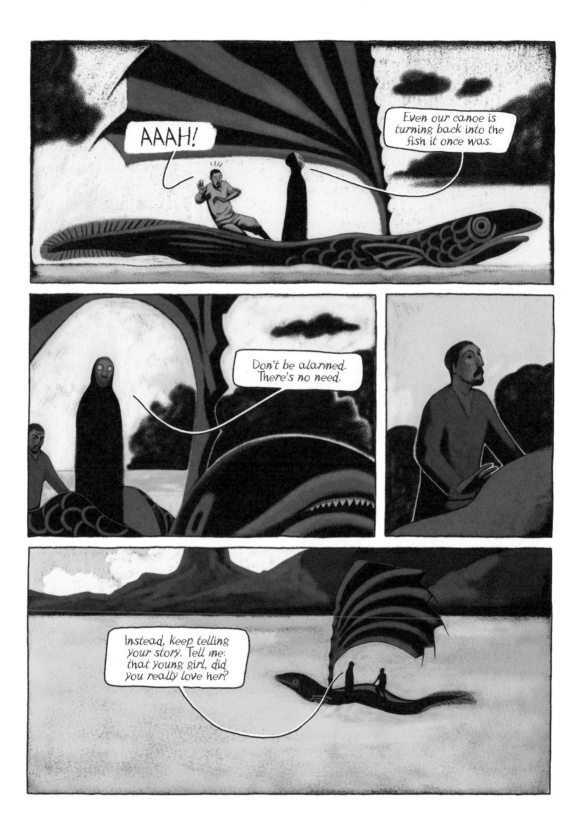

# 5
# Mahana no varua ino

# The day of
# evil ghosts

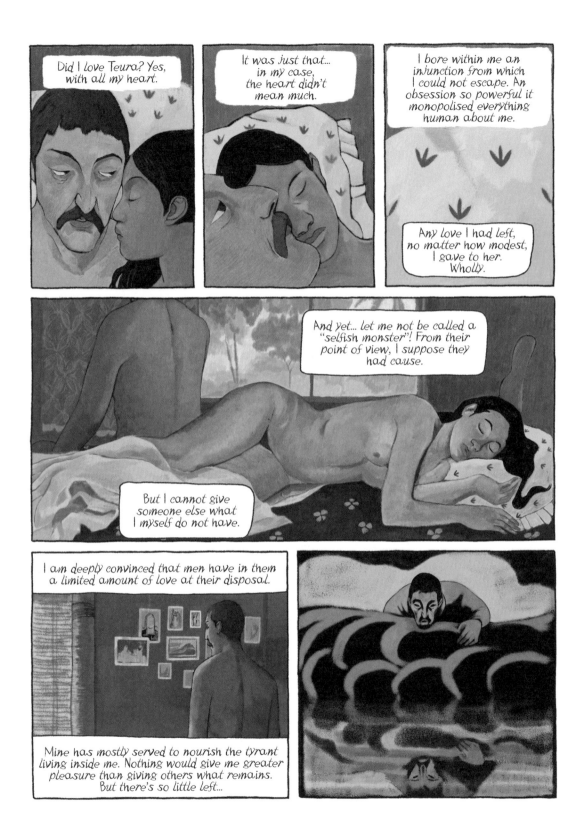

Did I love Teura? Yes, with all my heart.

It was just that... in my case, the heart didn't mean much.

I bore within me an injunction from which I could not escape. An obsession so powerful it monopolised everything human about me.

Any love I had left, no matter how modest, I gave to her. Wholly.

And yet... let me not be called a "selfish monster"! From their point of view, I suppose they had cause.

But I cannot give someone else what I myself do not have.

I am deeply convinced that men have in them a limited amount of love at their disposal.

Mine has mostly served to nourish the tyrant living inside me. Nothing would give me greater pleasure than giving others what remains. But there's so little left...

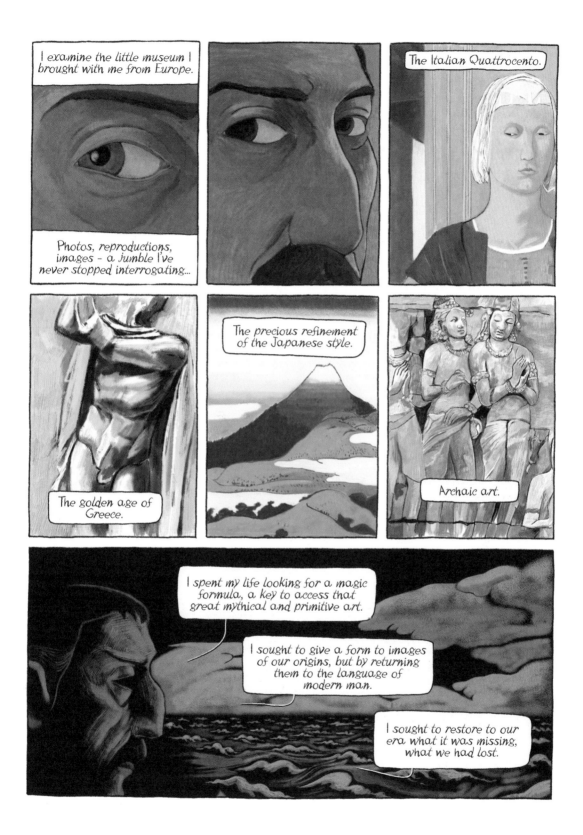

I examine the little museum I brought with me from Europe.

Photos, reproductions, images - a jumble I've never stopped interrogating...

The Italian Quattrocento.

The golden age of Greece.

The precious refinement of the Japanese style.

Archaic art.

I spent my life looking for a magic formula, a key to access that great mythical and primitive art.

I sought to give a form to images of our origins, but by returning them to the language of modern man.

I sought to restore to our era what it was missing, what we had lost.

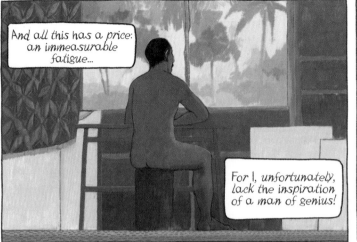

And all this has a price: an immeasurable fatigue...

For I, unfortunately, lack the inspiration of a man of genius!

I don't even have the knowledge of theory or ease of mind that comes with having method.

But I can count on my iron will. I have a blind confidence in my intuitions and, above all, in my insatiable desire to create and to be free.

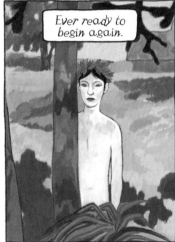

Ever ready to begin again.

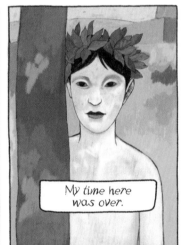

My time here was over.

Now I had to go back to Paris and show the fruits of my labours, have them recognised.

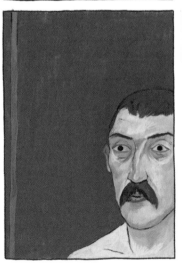

My canvases were all painted up and the money I'd had was gone.

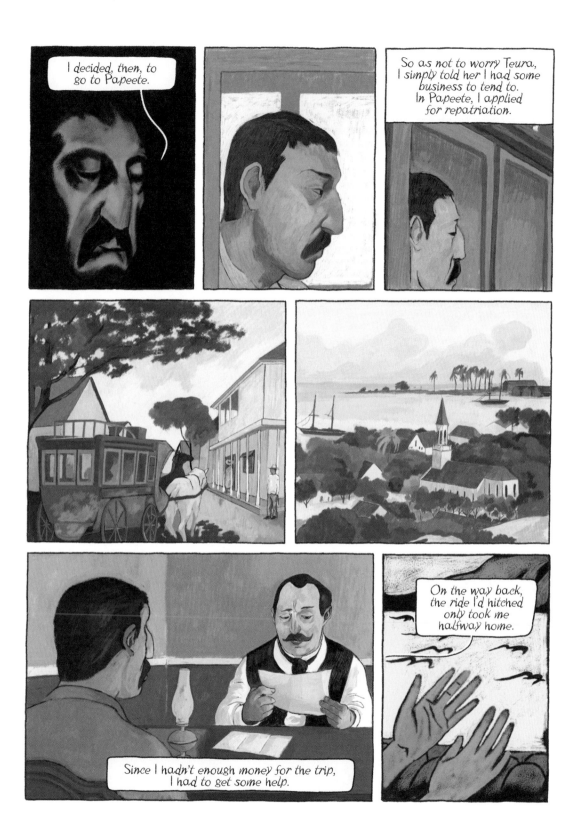

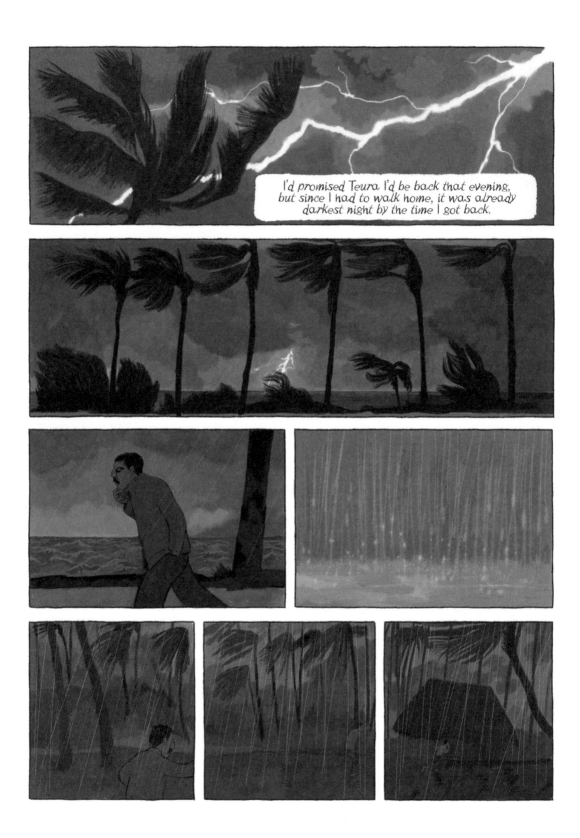

I'd promised Teura I'd be back that evening,
but since I had to walk home, it was already
darkest night by the time I got back.

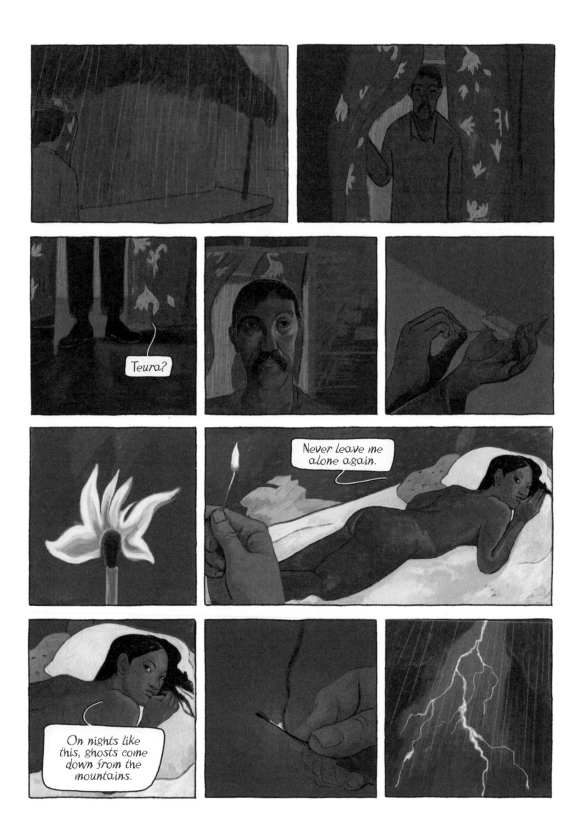

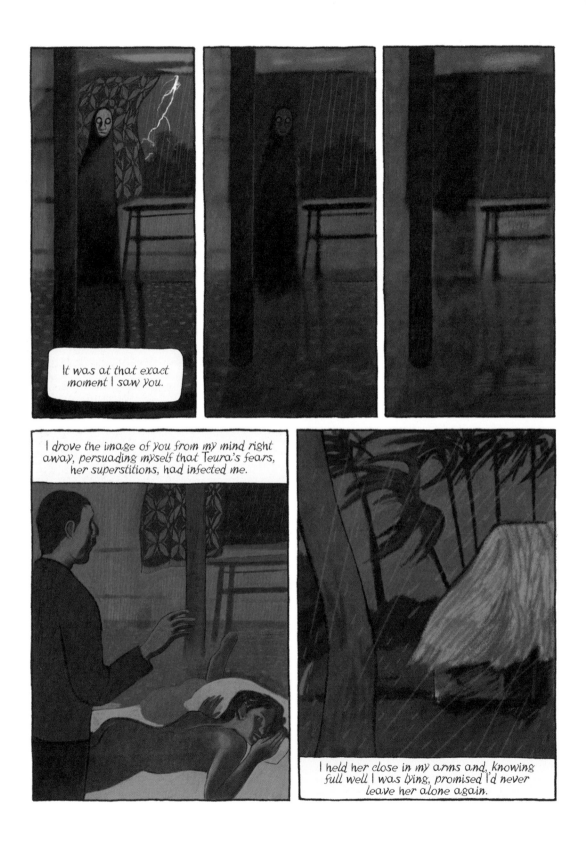

It was at that exact moment I saw you.

I drove the image of you from my mind right away, persuading myself that Teura's fears, her superstitions, had infected me.

I held her close in my arms and, knowing full well I was lying, promised I'd never leave her alone again.

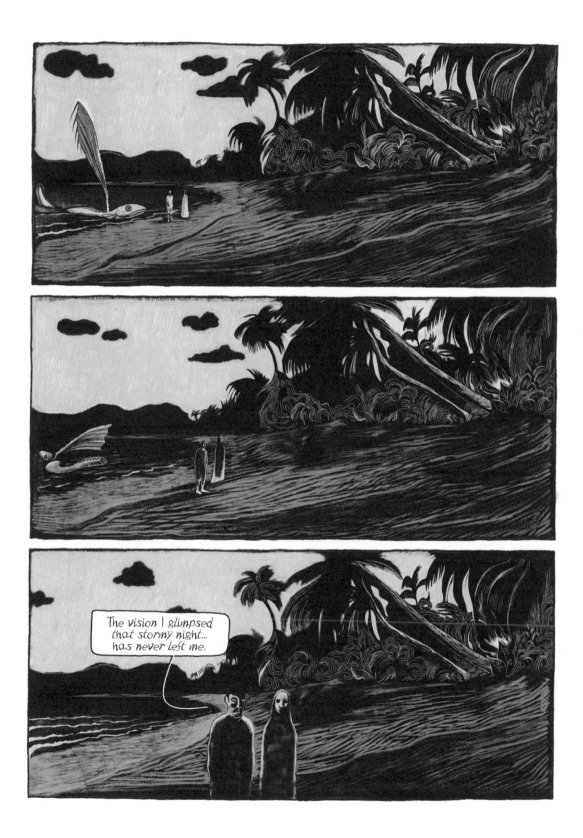

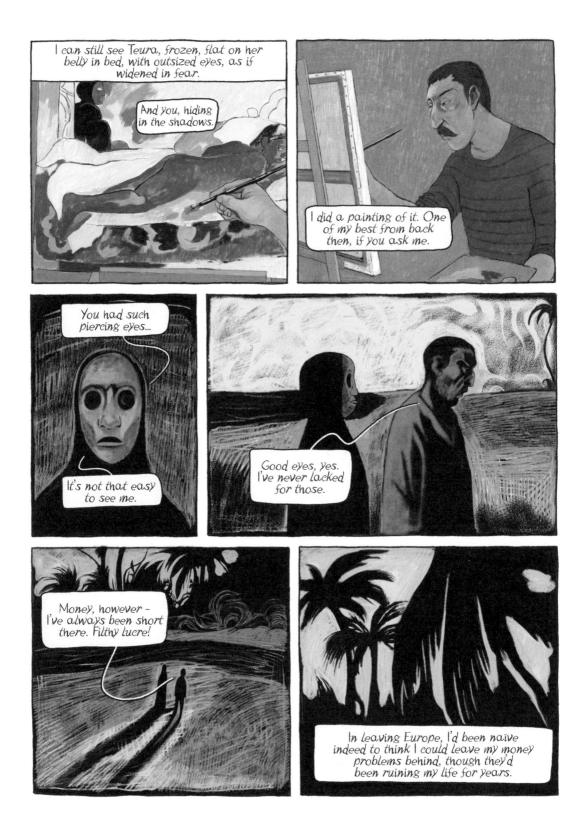

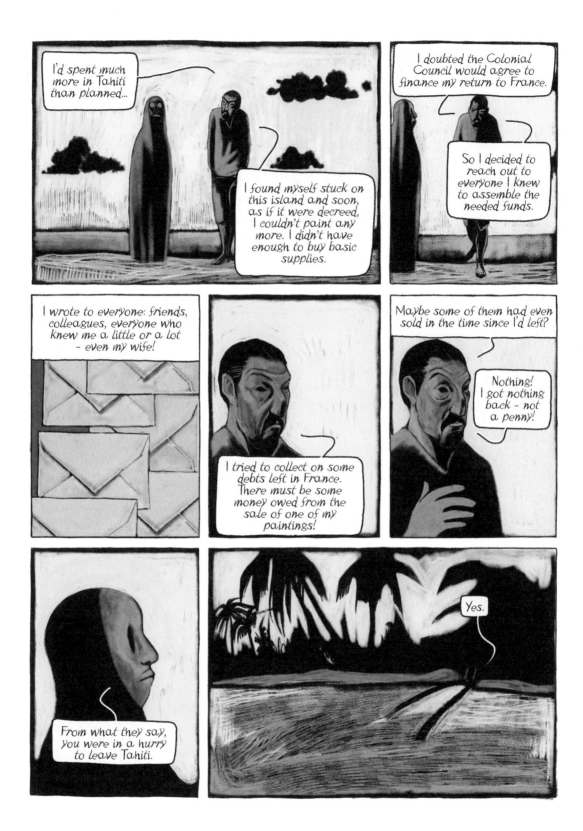

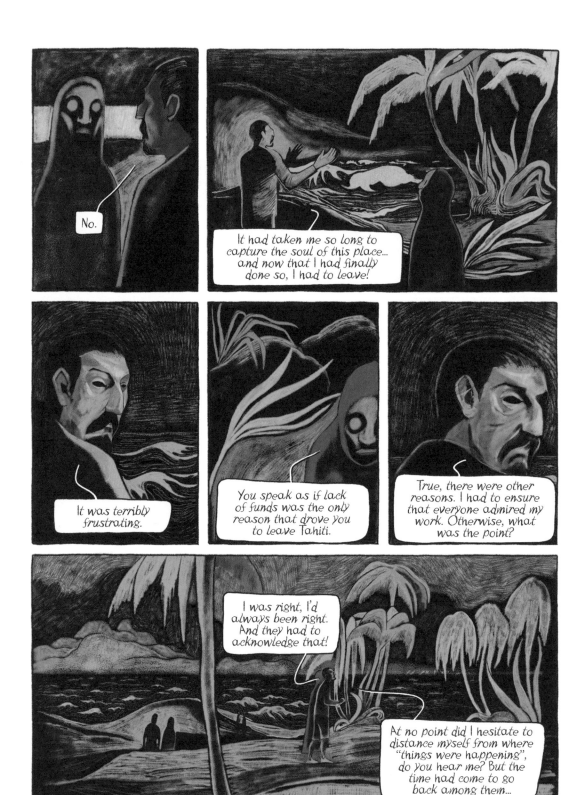

No.

It had taken me so long to capture the soul of this place... and now that I had finally done so, I had to leave!

It was terribly frustrating.

You speak as if lack of funds was the only reason that drove you to leave Tahiti.

True, there were other reasons. I had to ensure that everyone admired my work. Otherwise, what was the point?

I was right, I'd always been right. And they had to acknowledge that!

At no point did I hesitate to distance myself from where "things were happening", do you hear me? But the time had come to go back among them...

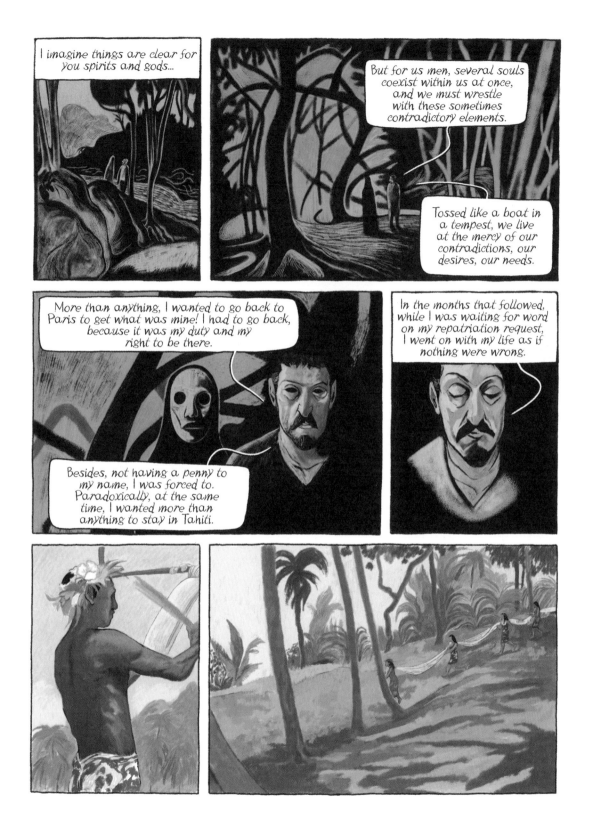

I imagine things are clear for you spirits and gods...

But for us men, several souls coexist within us at once, and we must wrestle with these sometimes contradictory elements.

Tossed like a boat in a tempest, we live at the mercy of our contradictions, our desires, our needs.

More than anything, I wanted to go back to Paris to get what was mine! I had to go back, because it was my duty and my right to be there.

Besides, not having a penny to my name, I was forced to. Paradoxically, at the same time, I wanted more than anything to stay in Tahiti.

In the months that followed, while I was waiting for word on my repatriation request, I went on with my life as if nothing were wrong.

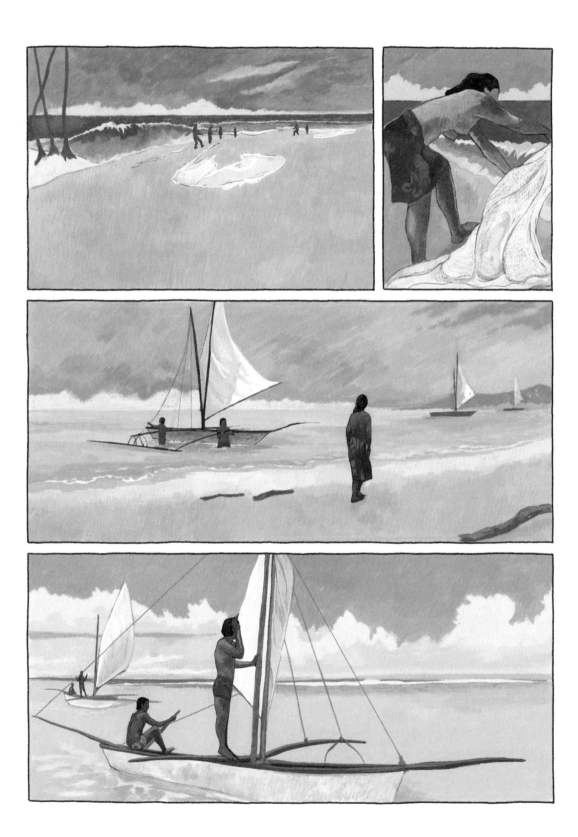

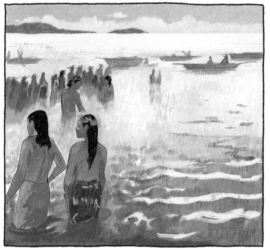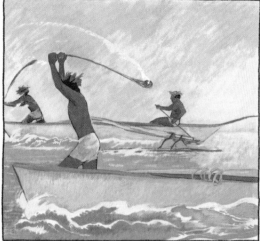

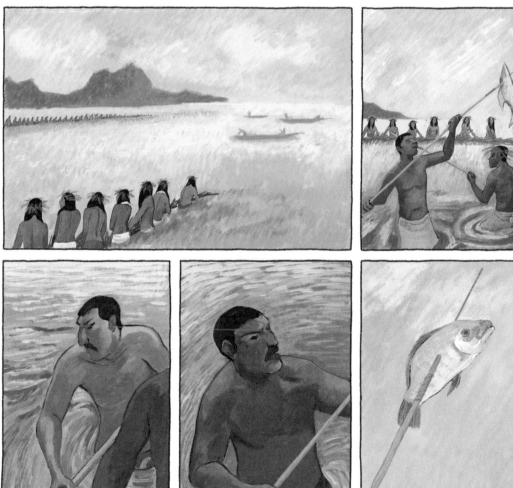

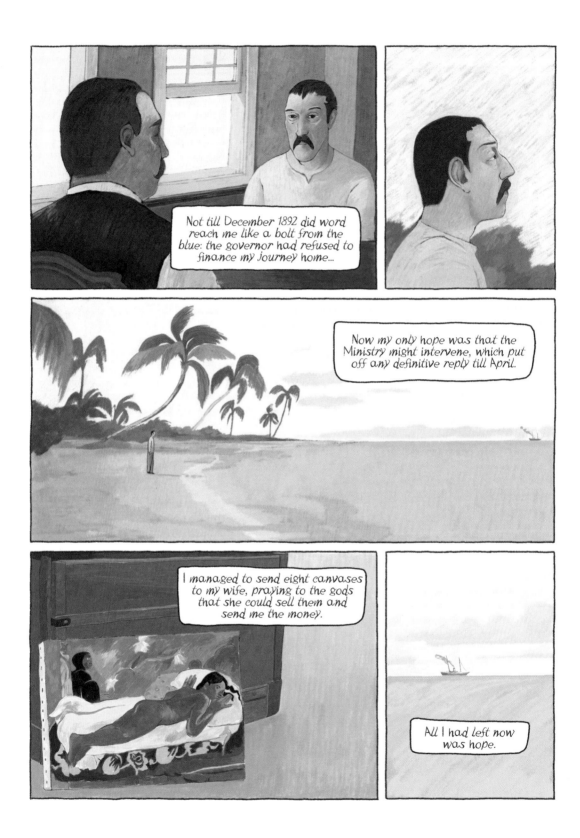

Not till December 1892 did word reach me like a bolt from the blue: the governor had refused to finance my journey home...

Now *my* only hope was that the Ministry might intervene, which put off any definitive reply till April.

I managed to send eight canvases to my wife, praying to the gods that she could sell them and send me the money.

All I had left now was hope.

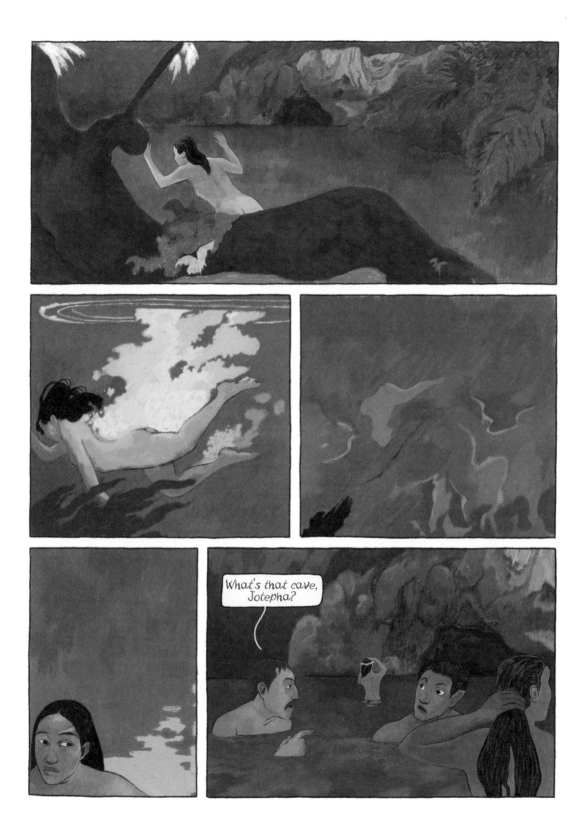

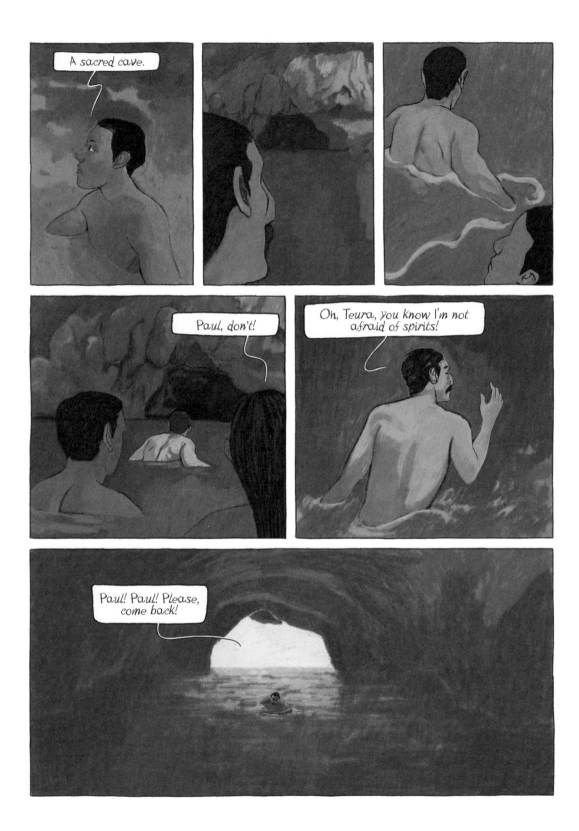

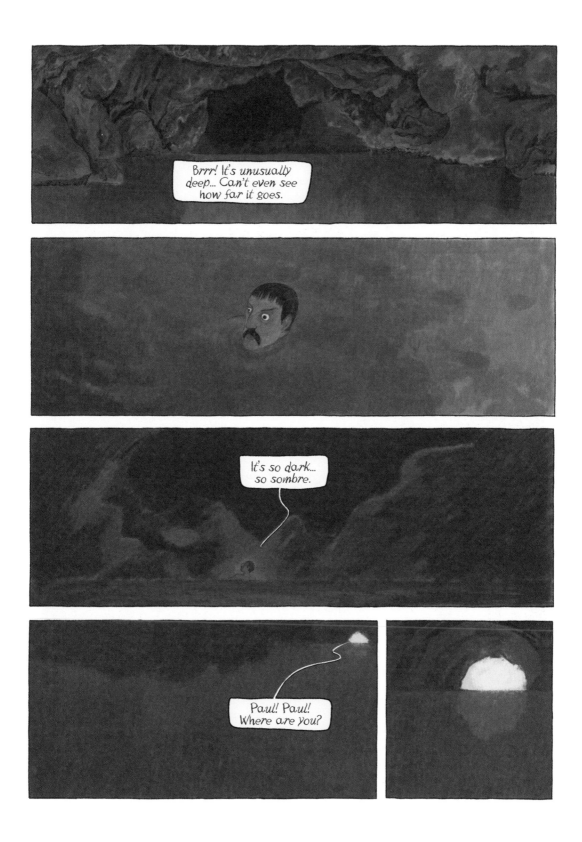

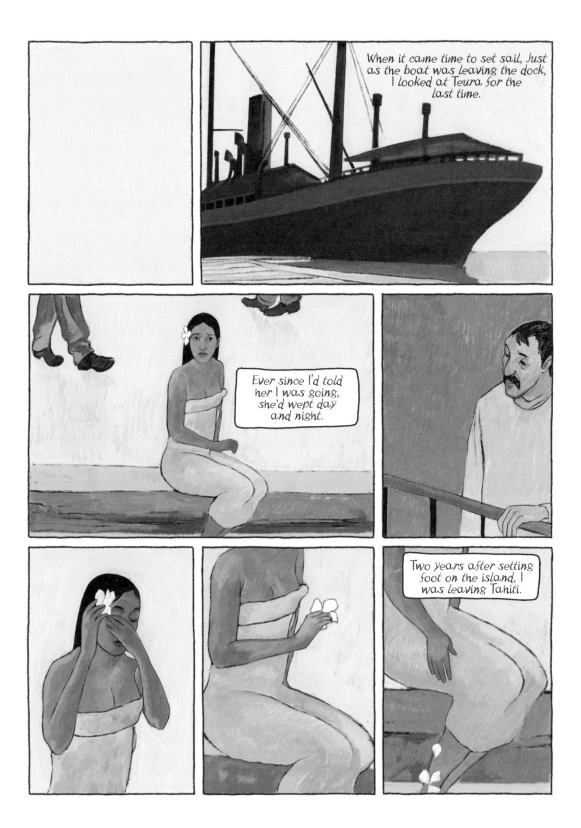

When it came time to set sail, just as the boat was leaving the dock, I looked at Teura for the last time.

Ever since I'd told her I was going, she'd wept day and night.

Two years after setting foot on the island, I was leaving Tahiti.

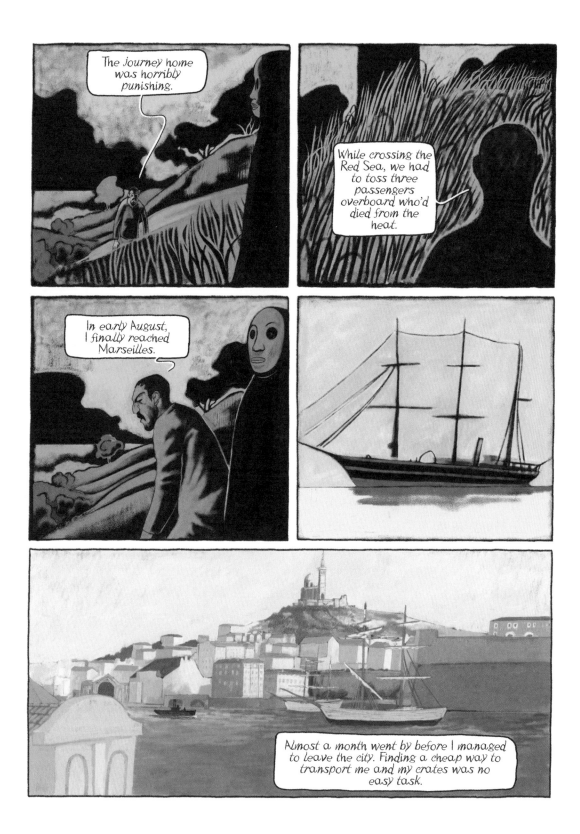

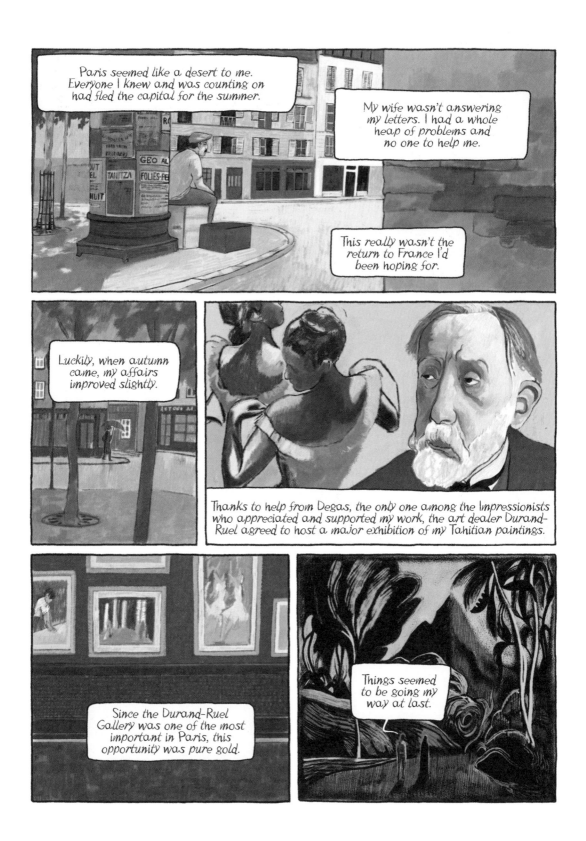

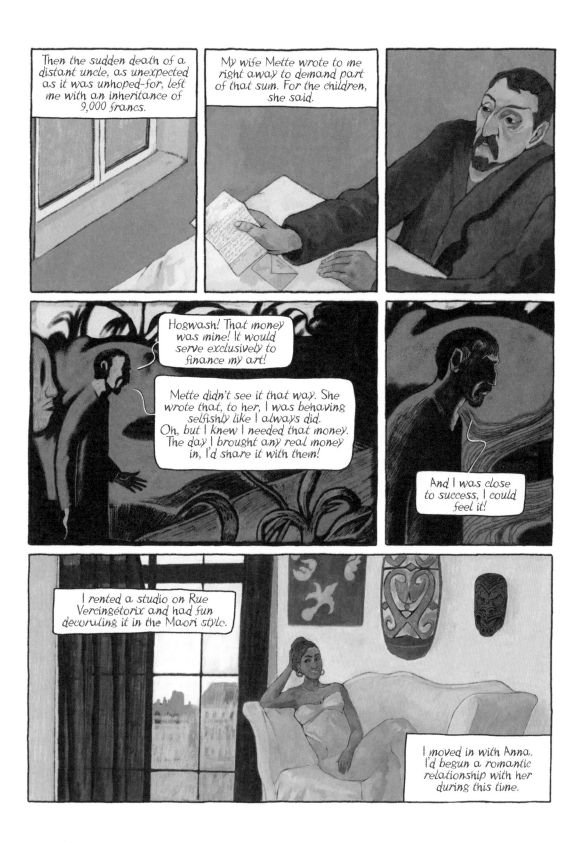

Then the sudden death of a distant uncle, as unexpected as it was unhoped-for, left me with an inheritance of 9,000 francs.

My wife Mette wrote to me right away to demand part of that sum. For the children, she said.

Hogwash! That money was mine! It would serve exclusively to finance my art!

Mette didn't see it that way. She wrote that, to her, I was behaving selfishly like I always did.
Oh, but I knew I needed that money. The day I brought any real money in, I'd share it with them!

And I was close to success, I could feel it!

I rented a studio on Rue Vercingétorix and had fun decorating it in the Maori style.

I moved in with Anna. I'd begun a romantic relationship with her during this time.

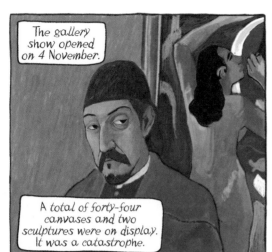

The gallery show opened on 4 November.

A total of forty-four canvases and two sculptures were on display. It was a catastrophe.

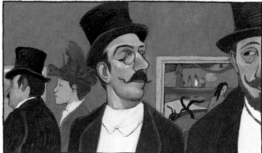

Many people came, but unfortunately they were drawn only by a taste for scandal. Well before its opening, the show had aroused much criticism. In the end, most people came only for a laugh at my expense.

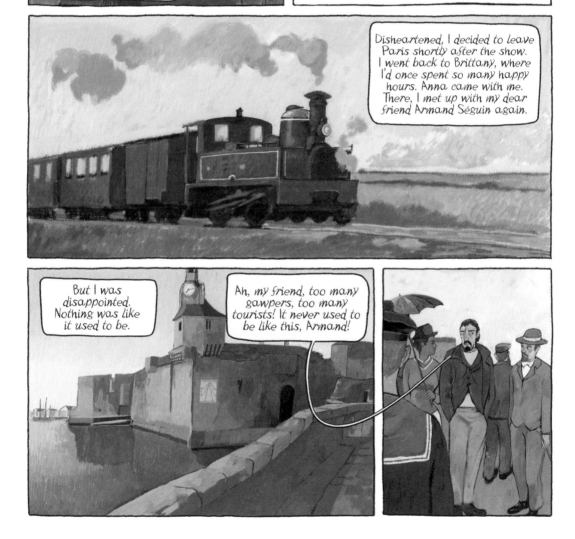

Disheartened, I decided to leave Paris shortly after the show. I went back to Brittany, where I'd once spent so many happy hours. Anna came with me. There, I met up with my dear friend Armand Séguin again.

But I was disappointed. Nothing was like it used to be.

Ah, my friend, too many gawpers, too many tourists! It never used to be like this, Armand!

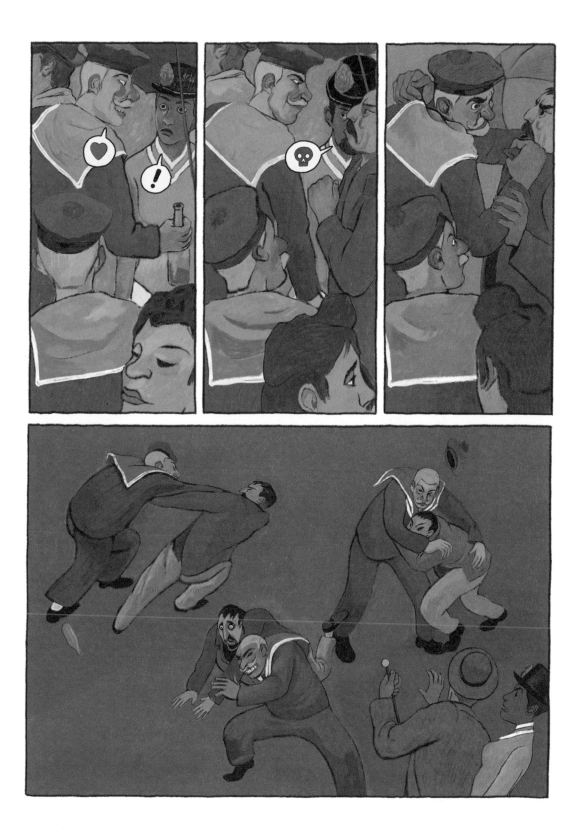

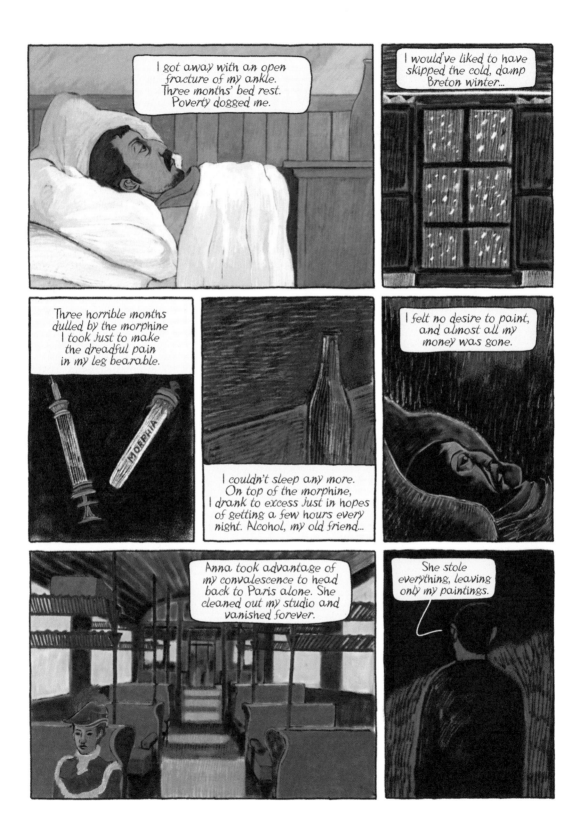

I got away with an open fracture of my ankle. Three months' bed rest. Poverty dogged me.

I would've liked to have skipped the cold, damp Breton winter...

Three horrible months dulled by the morphine I took just to make the dreadful pain in my leg bearable.

I couldn't sleep any more. On top of the morphine, I drank to excess just in hopes of getting a few hours every night. Alcohol, my old friend...

I felt no desire to paint, and almost all my money was gone.

Anna took advantage of my convalescence to head back to Paris alone. She cleaned out my studio and vanished forever.

She stole everything, leaving only my paintings.

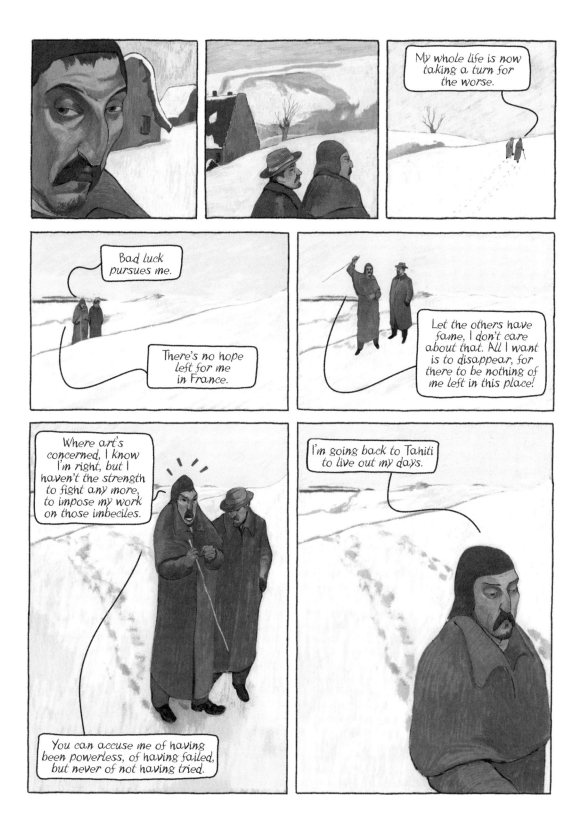

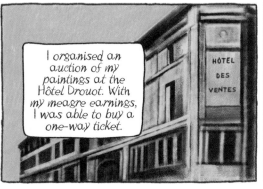

I organised an auction of my paintings at the Hôtel Drouot. With my meagre earnings, I was able to buy a one-way ticket.

HÔTEL
DES
VENTES

The few prints that decorated my studio on Rue Vercingétorix - the ones Anna hadn't deigned to steal - I gave away to my friends.

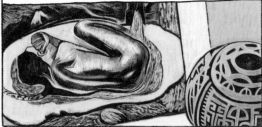

I reached Tahiti in July. It was 1895. To my great surprise, the streets of Papeete had just got electric lighting.

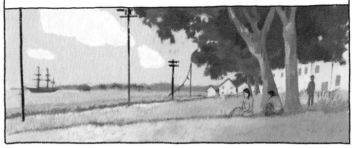

"Progress" - Europe - had preceded me.

I made no attempt to see Teura, and set myself up in the district of Pounoaouia, on the outskirts of Papeete.

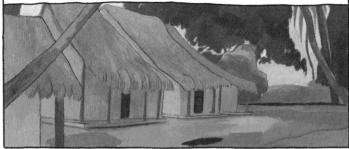

My leg was still hurting me.

Exhausted, drained, I didn't do much painting.

All those long, sleepless nights had taken their toll.

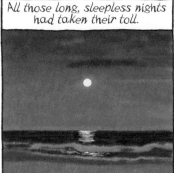

My health declined, but my carcass still put up a fight.

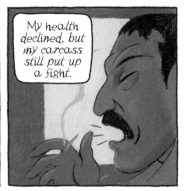

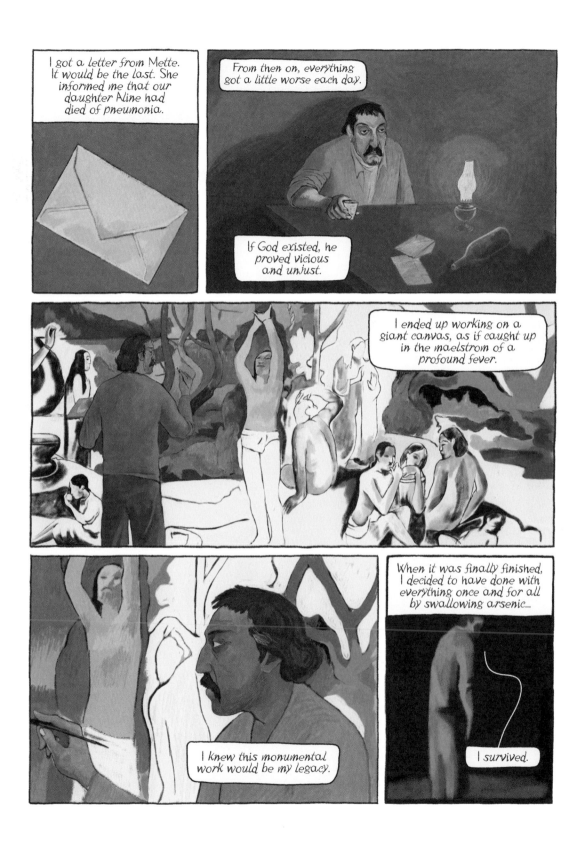

I got a letter from Mette. It would be the last. She informed me that our daughter Aline had died of pneumonia.

From then on, everything got a little worse each day.

If God existed, he proved vicious and unjust.

I ended up working on a giant canvas, as if caught up in the maelstrom of a profound fever.

I knew this monumental work would be my legacy.

When it was finally finished, I decided to have done with everything once and for all by swallowing arsenic...

I survived.

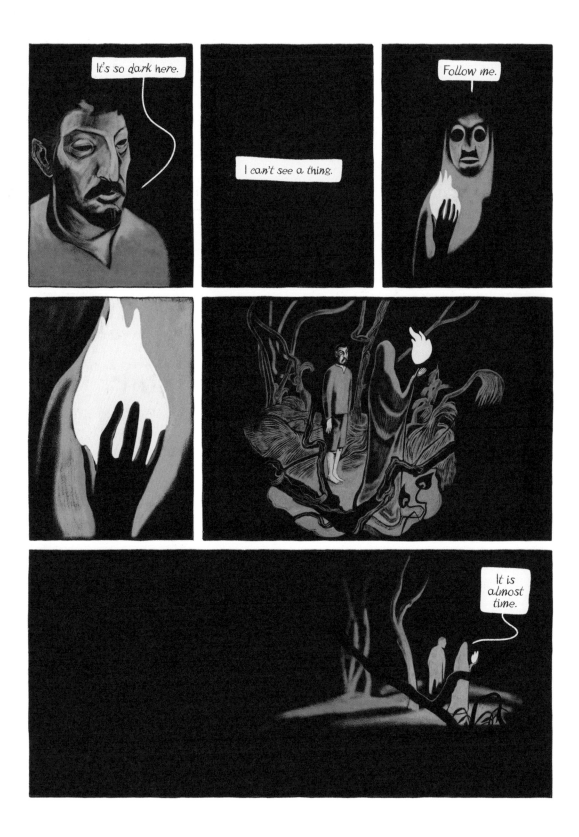

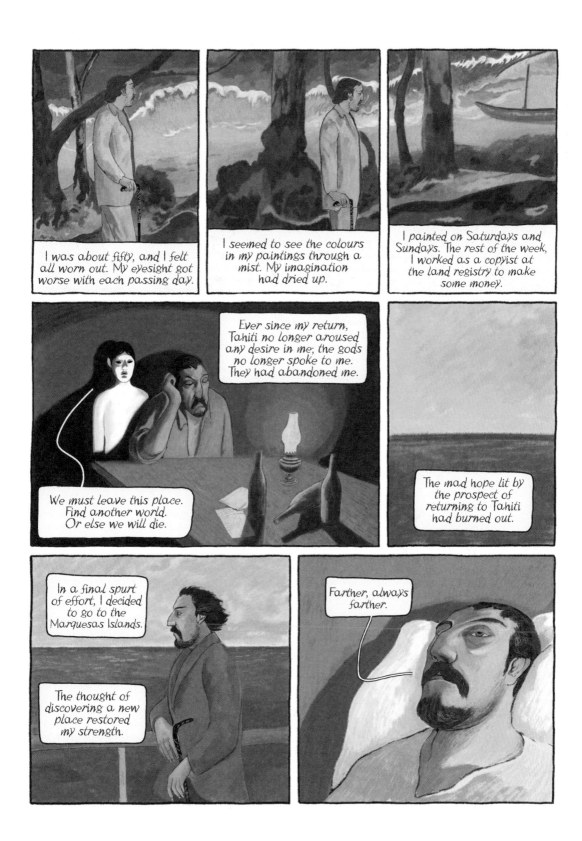

I was about fifty, and I felt all worn out. My eyesight got worse with each passing day.

I seemed to see the colours in my paintings through a mist. My imagination had dried up.

I painted on Saturdays and Sundays. The rest of the week, I worked as a copyist at the land registry to make some money.

Ever since my return, Tahiti no longer aroused any desire in me; the gods no longer spoke to me. They had abandoned me.

We must leave this place. Find another world. Or else we will die.

The mad hope lit by the prospect of returning to Tahiti had burned out.

In a final spurt of effort, I decided to go to the Marquesas Islands.

The thought of discovering a new place restored my strength.

Farther, always farther.

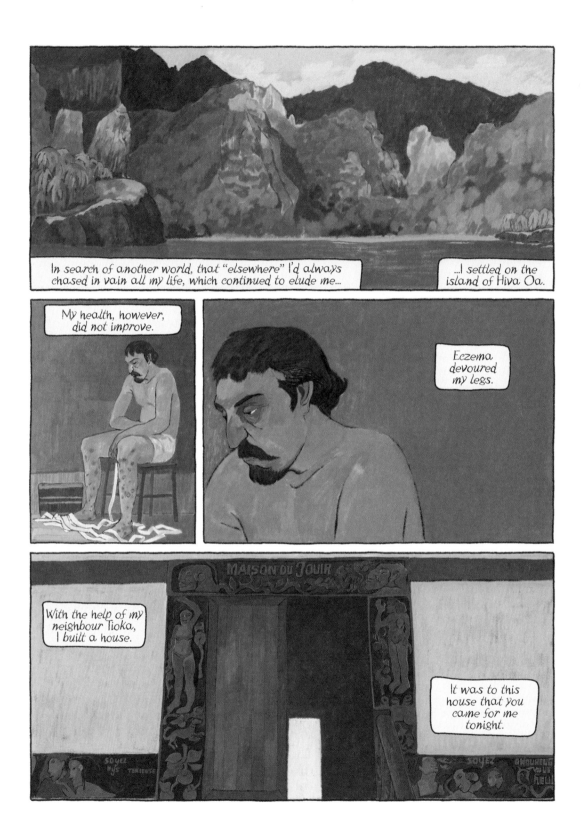

In search of another world, that "elsewhere" I'd always chased in vain all my life, which continued to elude me...

...I settled on the island of Hiva Oa.

My health, however, did not improve.

Eczema devoured my legs.

With the help of my neighbour Tioka, I built a house.

It was to this house that you came for me tonight.

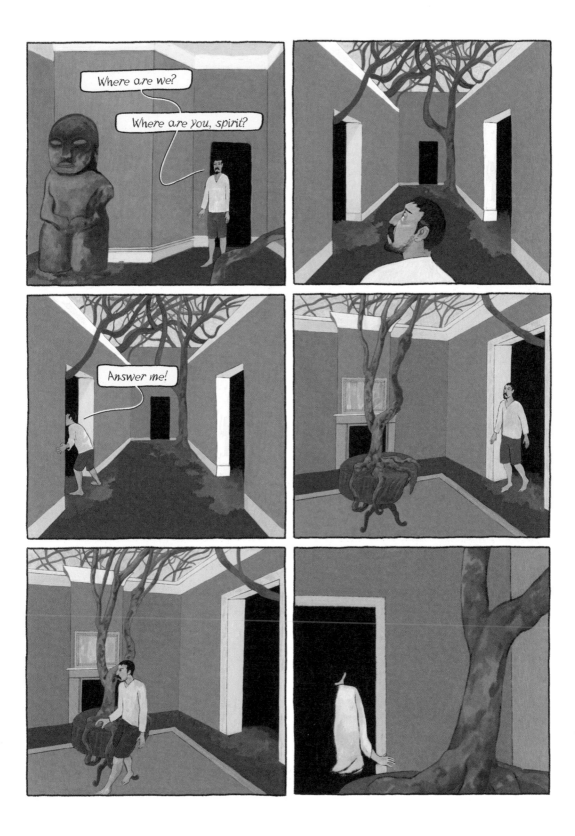

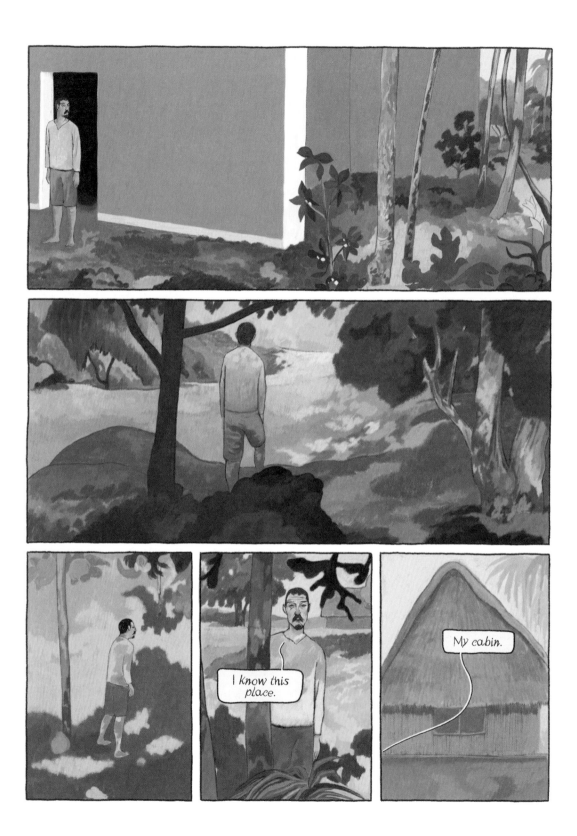

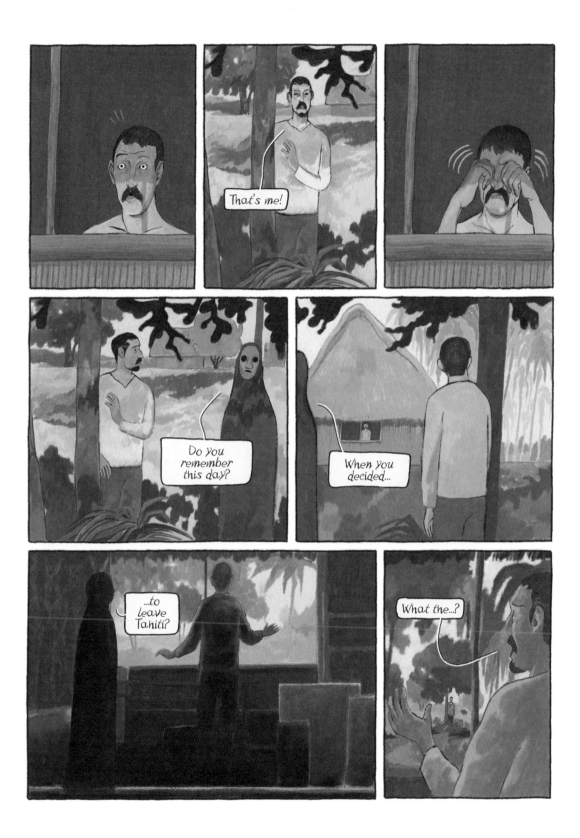

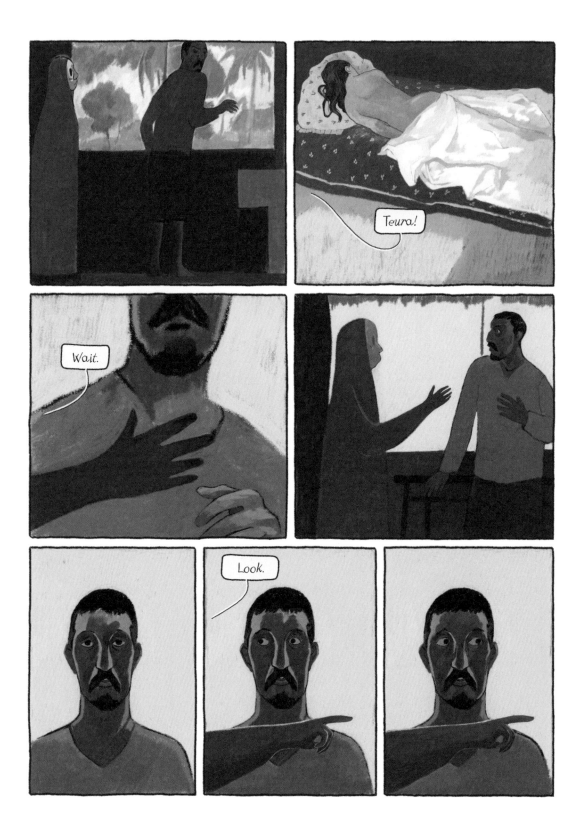

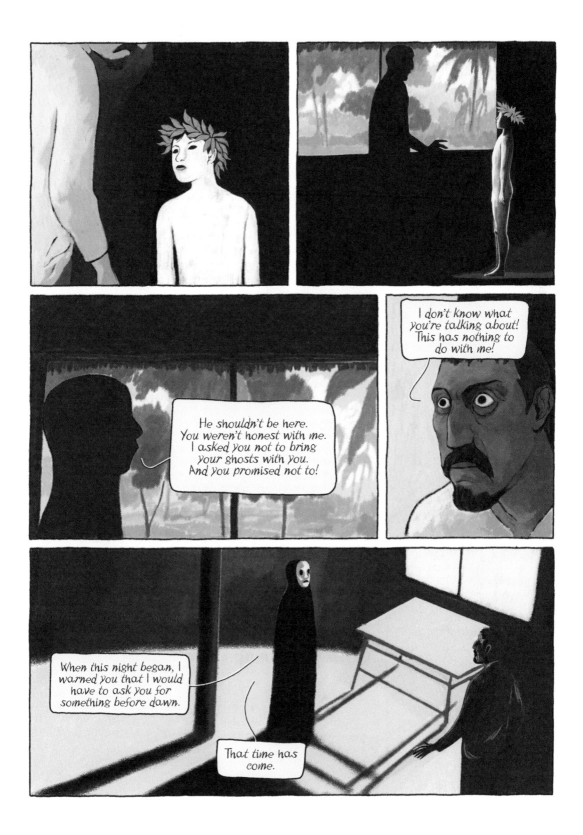

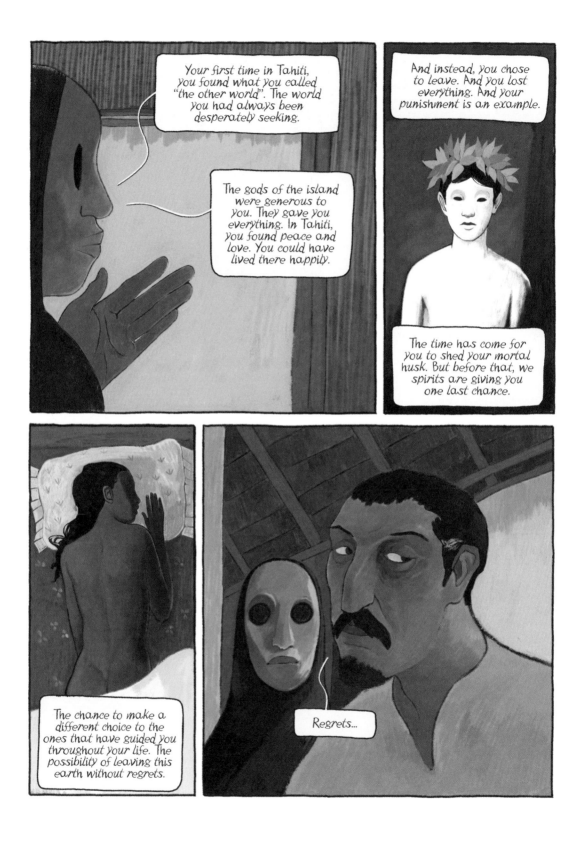

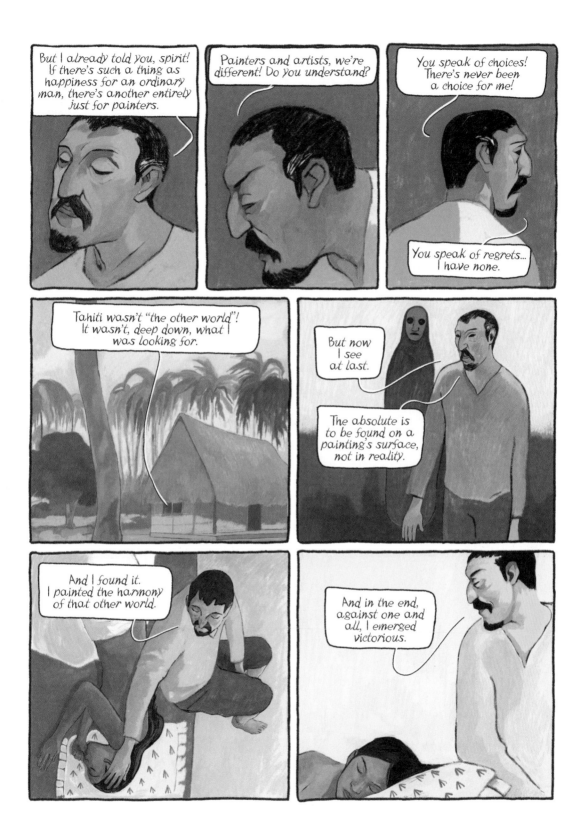

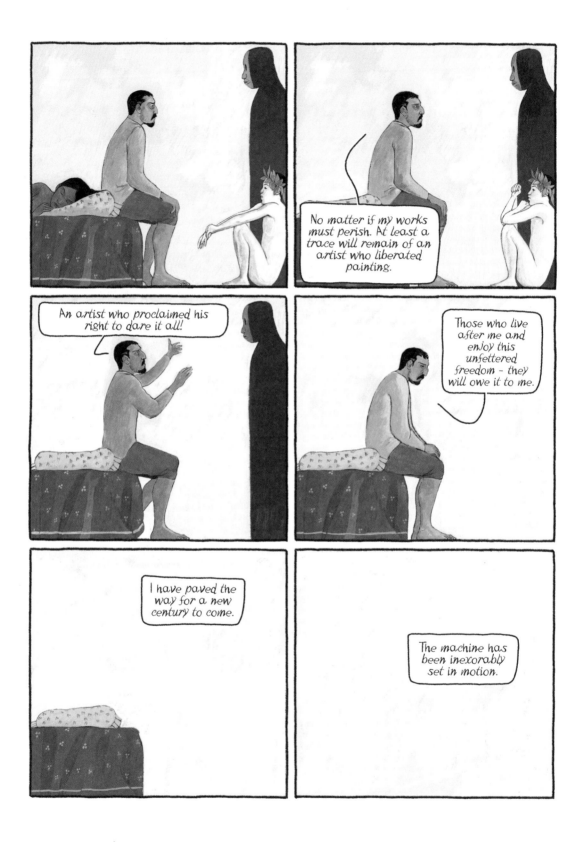

No matter if my works must perish. At least a trace will remain of an artist who liberated painting.

An artist who proclaimed his right to dare it all!

Those who live after me and enjoy this unfettered freedom - they will owe it to me.

I have paved the way for a new century to come.

The machine has been inexorably set in motion.

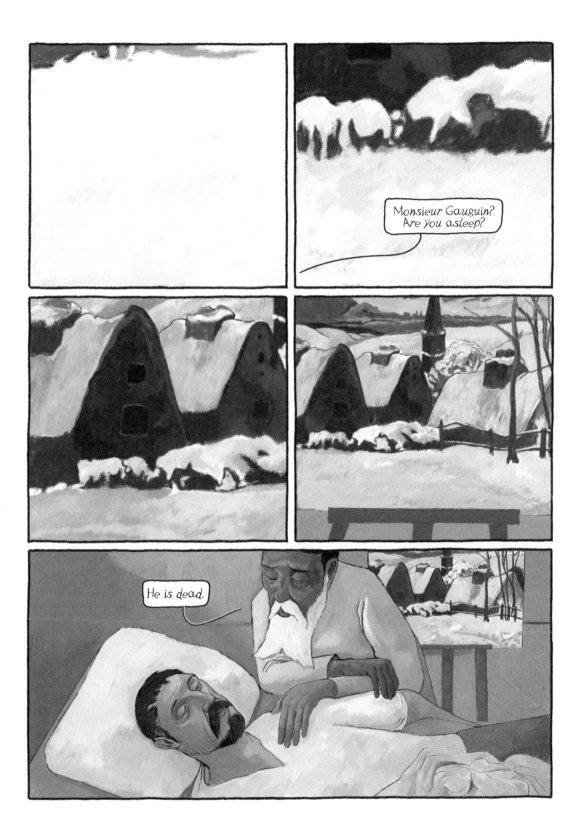

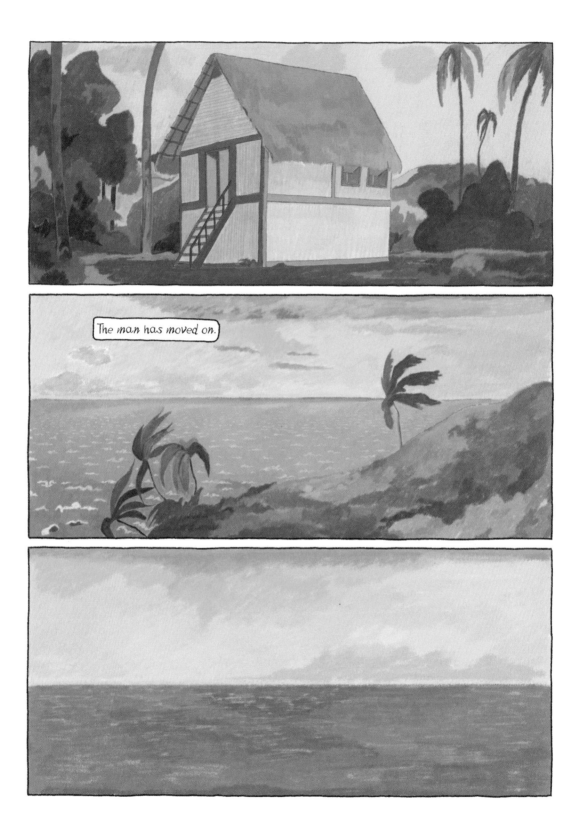

The man has moved on.

Paris, winter 1907.

"Extravagant, misshapen contours à la Gauguin."

They also say that of certain paintings by Matisse.

My word! They couldn't have given me a nicer compliment, even if I don't think they intended to.

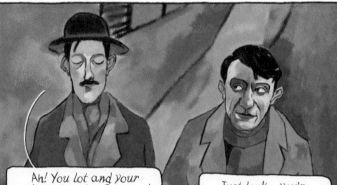

Ah! You lot and your admiration for Gauguin! Ever since his retrospective show last year, you've all gone mad!

Just look – you're collecting bizarre ebony statuettes from Africa!

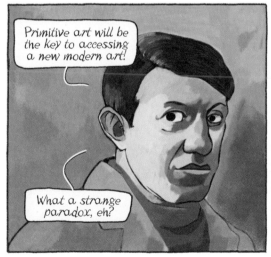

Primitive art will be the key to accessing a new modern art!

What a strange paradox, eh?

If you say so, Pablo...

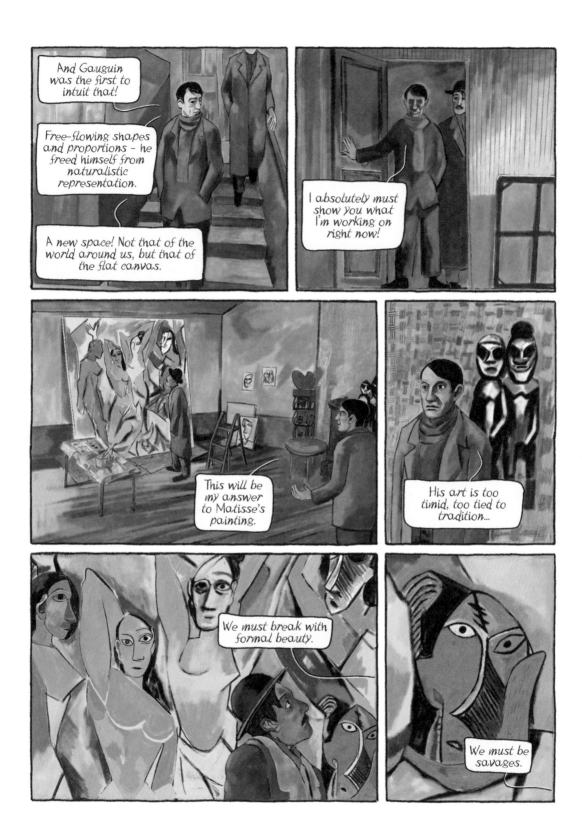

And Gauguin was the first to intuit that!

Free-flowing shapes and proportions – he freed himself from naturalistic representation.

A new space! Not that of the world around us, but that of the flat canvas.

I absolutely must show you what I'm working on right now!

This will be my answer to Matisse's painting.

His art is too timid, too tied to tradition...

We must break with formal beauty.

We must be savages.

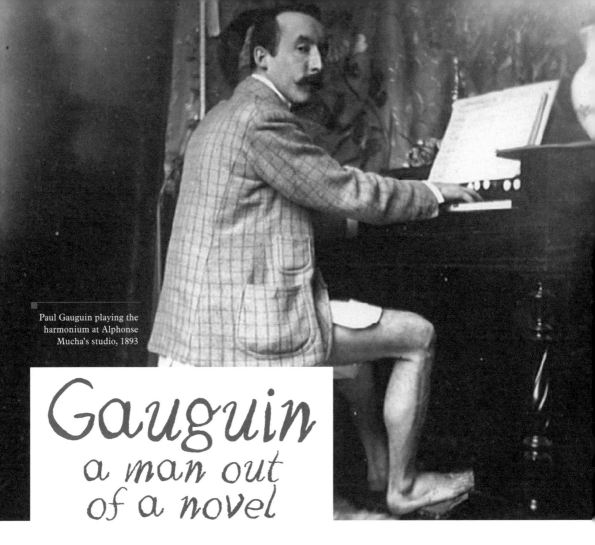

# Gauguin
## a man out of a novel

*It's hardly surprising that writers have been unable to resist the pleasure of making Paul Gauguin a fictional character: the artist's life was already like a novel.*

His upbringing was at once aristocratic and exotic. The son of a politically revolutionary journalist who died young, Paul Gauguin was by turns a young globetrotting sailor, a brilliant stockbroker, a somewhat bohemian bourgeois family man and a fascinating outcast painter of young poets, influential to generations of artists. He finally exiled himself to the tropics, where he died a solitary recluse; his fifty-five years of life on this earth, from 1848 to 1903, leave us flabbergasted.

A single person suffices to lend Gauguin's family origins an aura of myth: his grandmother Flora Tristan. This Franco-Peruvian beauty claimed imperial ancestry, making a name for herself as a muse to the Romantic Socialists and as a pioneering feminist. Gauguin spent his childhood in Peru, but never knew his extraordinary grandmother – it took writer Mario Vargas Llosa, a century after the artist's demise, to intertwine the fates of these two idealistic rebels in a novel, *The Way to Paradise*.

Uninterested in schooling and unhappy with the grey Parisian weather, Paul Gauguin signed on as a sailor at age seventeen. He would travel the Mediterranean and the Black Sea, return to South America and explore the Great North and the Indies before returning to settle in Paris six years later. Then began an

episode of his life that seems to exist only for contrast with his inevitable destiny as an artist. Starting in 1872, Gauguin successfully launched a career as a stockbroker, married a young Danish woman with whom he would have five children and led the life of an enlightened young man of the middle class. He built up a collection of Impressionist works, and in his free time painted as an amateur. But ten years later, this comfortable life slipped away from him forever: he lost his job and his wife – who fled to Denmark with his children – and, most importantly of all, he decided to devote himself fully to his artistic activities. It was this tipping point that Somerset Maugham would dramatise. In his novel *The Moon and Sixpence*, Maugham introduces a hero with a strong resemblance to Gauguin whose all-consuming passion for painting destroys everything in its path.

"I got it in my head that I would become a painter," Gauguin wrote to Camille Pissarro in 1882. From then on, he reinvented himself as a martyr to his artistic cause. Time and again, he depicted himself as a Christlike messiah, and in letters to his wife and friends complained endlessly about the poverty and solitude to which painting doomed him. At the same time, Gauguin constructed a character for himself: charismatic to some, terrifying to others. "His curious physiognomy,

> ## "I got it in my head that I would become a painter"

his extravagant appearance and a certain wild air about him that my father had pointed out many times as signs of his megalomania made me keep my distance," wrote the son of the famous psychiatrist Dr. Blanche.

Playing on this image of the cursed and outcast painter in a self-portrait for Vincent van Gogh, Gauguin identified with Jean Valjean, the desperate hero of *Les Misérables*. The brief bond between the two artists ended with the famous and tragic episode of the severed ear. This passionate act led to van Gogh being committed in Arles; Gauguin was never to see him again. Here, then, is another episode

novelists and filmmakers have turned to their advantage…

In 1891, after the artist announced his departure for Tahiti, writer Octave Mirbeau described him as "a man fleeing civilisation": "His intention was to live there for several years all alone, build a hut there and go back to work on the things that haunted him." When he returned to Paris in the winter of 1893, Gauguin adopted a look that was half dandy, half noble savage: "To Parisians, he looked like a sumptuous and towering Magyar, a Rembrandt from 1635, as he made his way slowly, sombrely along, leaning with one white-gloved, silver-braceleted hand on the cane he'd decorated himself," recalled chronicler Armand Séguin. As his public persona grew, Gauguin did not hesitate to put himself in

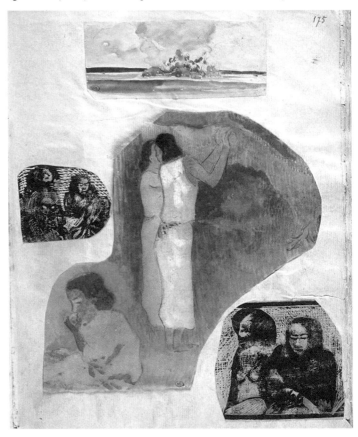

■
**A page from the illustrated manuscript of *Noa Noa***
Paul Gauguin, *Tahitian Woman and Couples in Nature*. Page from the travelogue *Noa Noa*, 1894–1901, leatherbound volume, 31.4 x 24 cm

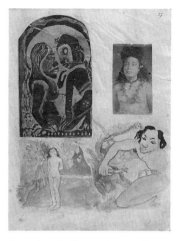

A page from the illustrated manuscript of *Noa Noa*

the limelight and promote his work: he painted the walls of his studio on Rue Vercingétorix in Montparnasse bright yellow, adorned the windows with Tahitian landscapes, surrounded himself with spectacular, exotic odds and ends and received his friends in the company of his young Javanese mistress, a parrot and a small monkey.

When he left France once more in 1895, Gauguin, embittered and grandiloquent, declared that he would never again return. He was right. The end of his life corroborates the cliché of the doomed, outcast artist, cursed by society, that Gauguin had often exploited for purposes of provocation. He died alone – sickly, irascible, suicidal and alcoholic. When the news reached France, journalists would especially emphasise the scandalous aspects of his life – alcohol, morphine, fights and native women – which for a long time kept his art from just recognition. But what he left young artists still coming into their own was a memory filled with admiration: "[He was] the uncontested master, the one you looked to, whose paradoxes you gossiped about; you admired his talent, his loquacity, his gestures, his physical power, his nastiness, his inexhaustible imagination, his head for drink, the way he romanticised faraway places," painter Maurice Denis wrote in 1903.

A few months after his death, poet Victor Segalen paid a visit to the artist's final resting place in the Marquesas Islands, a majestic cabin of sculpted wood known as the 'House of Pleasure'. He got an article, a eulogy and then a short story out of his trip, thus inaugurating the impressive literary fortunes of the character known as Gauguin.

# Gauguin
## writer

*If Paul Gauguin resembles a fictional hero, it's because he never passed up a chance to embroider his own myth.*

Throughout his life as an artist, Gauguin revealed himself through copious letters: he wrote to his wife and his friends – artists, poets and critics. More than simply maintaining intimate ties, this correspondence also provided a space to reflect upon art and being an artist. Gauguin loved expounding his ideas and excelled at it; amused by his gift for public speech, Edgar Degas nicknamed him "The Professor". For Gauguin, writing was also a way of thinking through the evolution of his practice as an artist: "This year, I sacrificed everything – execution, colour – for style, wishing to impose something on myself other than what I knew how to do. This is, I believe, a transformation that has not yet borne fruit, but someday will," he wrote to his friend Émile Schuffenecker in 1888. Gauguin's letters also reveal the very real pleasure he took in writing. He was sure enough of his literary verve to imagine being published repeatedly. He felt a need to give his own personal version of his journey: "If I tell you that on my mother's side I am descended from a Borgia of Aragon, Viceroy of Peru, you will say it's a lie and call me pretentious." In his autobiographical writings, the artist sometimes exaggerates, but hardly ever lies.

Still, beyond its autobiographical dimension, the practice of writing for Gauguin denotes more than anything else an unquenchable thirst for research. When he first reached Tahiti, he was disappointed that no traces of the ancient Maori culture remained. So he set himself the task of gathering information on

Paul Gauguin kept a notebook for his daughter Aline in which, among other reflections on art, love and life, he explains the "genesis of a painting": "The title *Manaó Tupapaù* has two meanings: either she is thinking of a spirit or a spirit is thinking of her. To sum up: the musical part: undulating horizontal lines, harmonies between blue and orange joined by yellows and purples, varying shades of them lit by greenish flashes. The literary part: the spirit of a living woman linked with the spirit of the dead. Night and day."

accompany an exhibition. Back in Paris, he asked the poet Charles Morice to collaborate with him on his project: he wished to alternate the comments of a 'civilised man' (Morice) with the tale of a 'savage' (himself). He then presented the information about Maori culture at his disposal as secrets told to him by his *vahine*, Teura – the name he gave his native wife Teha'amana. In reality, there was no way the young girl could have possessed such knowledge. Gauguin wished to show the entire nature of his experience as a 'savage'. In much the same spirit, he gave his paintings titles in the Maori tongue

the subject. From a work by a former diplomat, he drew information on the history and ethnography of Oceania. He copied out long passages by hand into a richly illustrated notebook that furnished him with the basis for his work; thus did the deities and legends of Oceania find new life in his paintings and sculptures. In 1893, Gauguin sought to have this notebook, entitled *Ancien Culte Mahorie* [*Ancient Maori Worship*], published in order to disseminate an unjustly neglected culture among Europeans. At the same time, he undertook the writing of another book in which he combined commentary on this lost civilisation with his own memories. This time, the work was meant to provide an understanding of his painting and

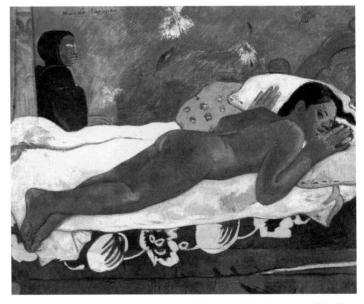

*Manaó Tupapaù* (*Spirit of the Dead Watching*), 1892, oil on canvas, 73 x 92 cm

Buffalo, Albright-Knox-Art Gallery

to augment their exotic nature in the eyes of a Parisian audience. The magnificent manuscript *Noa Noa*, of which Gauguin made several versions illuminated with watercolours, photographs and engravings, would only be published after his death in 1923.

In the end, Gauguin's taste for controversy was another thing that led him to take pleasure in writing. In Tahiti, he contributed to satirical revues in which he violently attacked missionaries and the colonial administration, though never without humour. For a while, he found amusement in distributing a newspaper entirely of his own creation, down to every last article and illustration. Towards the end of his life, weakened by illness, he devoted most of his time to writing. He wrote a new autobiographical work, *Avant et Après* [*Before and After*], in which he denounced the unfairness that society and his family had shown him. Finally, in his *Racontars de Rapin* [*Tales of Plunder*], he paid tribute to artists he admired, from Raphaël to Degas, humbly referring to himself as an eternal apprentice or, more bitterly, as a man thought to have the look of a painter but not the skill.

> "This year, I sacrificed everything – execution, colour – for style..."

# Gauguin
## modern and savage

*Impressionist, Synthetist or Symbolist? It was by establishing himself as a 'savage' that Paul Gauguin imposed his resolutely modern style on the world.*

Paul Gauguin came to painting just as art was embarking on Modernism. In 1879, the young self-taught amateur was invited to show his works alongside the Impressionists. Under the guidance of Pissarro, he mastered their style – primacy of light and feeling. From Degas, he retained a compositional boldness; from Cézanne, a system for constructing with colours.

Starting in 1886, when he sought to transcend this movement, he took his first step toward 'faraway places' in search of 'savagery'. In Pont-Aven, Gauguin appreciated being received as an Impressionist – "Me, an Impressionist? You mean a rebel" – as long as the label allowed him to set himself apart. In 1889, he added the label of Synthetist: the style, perfected by the young painter during stays in Brittany, consisted of synthesising one's impression of a reality. What resulted was a simplification on the level of drawing, use of pure colours and rhythmic compositions in a decorative spirit. And this is where the tipping point toward Modernism is located: the painting becomes an end in itself. As Maurice Denis sums up perfectly: "Remember that before being a warhorse, a nude woman or an anecdote of daily life, a painting is essentially a flat surface covered in colours assembled in a certain order."

Gauguin's works almost always combine a traditional, often religious theme with an imaginary scene. This allowed him to pass as a Symbolist in 1890, though he remained too much an observer of nature to be associated with the movement.

In reality, it was Gauguin's quest for the 'savage state' that allowed him to occupy a unique place in art history. In his still-Romantic attraction to exotic things, Gauguin remained a man of the 19th century. But when he sought lively sources for his creation in his 'savage' uneducated self and drew on the fantasised origins of art – whether childish, archaic, sacred, popular or 'savage' – he anticipated the most modern inspirations of 20th-century art.

**Céline Delavaux**

# Also available in the **ART MASTERS** series:

**VINCENT**
by Barbara Stok

ISBN 978-1-906838-79-9
Paperback, 144 pages
RRP: UK £12.99
US $19.95  CAN $21.95

**MUNCH**
by Steffen Kverneland

ISBN 978-1-910593-12-7
Paperback, 280 pages
RRP: UK £15.99
US $24.95  CAN $29.95

**PABLO**
J. Birmant and C. Oubrerie

ISBN 978-1-906838-94-2
Paperback, 344 pages
RRP: UK £16.99
US $27.50  CAN $33.50

**DALÍ**
by Baudoin

ISBN 978-1-910593-15-8
Paperback, 160 pages
RRP: UK £12.99
US $19.95  CAN $23.95

**Available in all good bookshops**